A HISTORY OF

CAMP CORY

BO SHOEMAKER

FOREWORD BY MARK DIBBLE, CAMP DIRECTOR, 2003–2010

THE
History
PRESS

ISBN 978-1-5402-2107-0

Library of Congress CIP data applied for.

For Mark Dibble, Dave Ghidiu and Bill Smith: storytellers extraordinaire, magicians superb and mentors exemplary.

.

CONTENTS

FOREWORD

I first met Bo Shoemaker in the summer of 1996. He was a twelve-year-old Maijgren camper, and I was a seventeen-year-old junior counselor. Given that I was already such an "adult" and he just an immature preteen, I gave him little notice. My most vivid memory of him is of the life jacket he wore: it had an odd band around the top that resembled the collar on a dress shirt, except with thick padding. I assumed the jacket was a special adaptation for some sort of medical condition that afflicted Bo. In fact, for years to come, I thought of Bo as the child who was unable to support the weight of his own head.

When I first saw Bo and his odd life jacket, it didn't occur to me that he would some day become one of my closest friends. But of course, this is the great thing about Camp Cory—the indelible relationships we all form. Not only have all of my closest friends all come from Camp Cory, but Camp Cory has also brought me closer to older brothers who both attended camp and to my parents, who were nearly as heartbroken as I was when I completed my final season at camp in 2010. They had been driving to Camp Cory every summer for over twenty-five years, and even though I was thirty-one when I spent my final summer at camp, they still made that trip several times that summer.

As I have aged, neighborhood friends have become distant acquaintances, high school confidants have become pleasant memories and many close friends have become little more than pen pals. The exception to this is, of course, my camp friends. My friendships from camp, built on a few fleeting weeks spent together each summer, have emerged in adulthood as having

the most solid foundation of all the relationships in my life. These are the friends in my life that I can go months, sometimes even years without speaking to, only to reconnect and immediately have that special intimacy shared with only the oldest of friends. Perhaps these relationships are so strong because they were established based on perennial and all-too-long times apart. More likely, however, it is just the nature of the place. I know of no other environment that breaks down interpersonal barriers quicker, removes people's inhibitions faster or allows for a more complete loss of self-consciousness than Camp Cory. As a whole, I have never known Camp Cory to be anything less than completely accepting of all people. It is the place in the world where I was first comfortable being myself, and it is the people from Camp Cory that know me better than anyone else in my life.

Over the years, I have heard many people express very similar sentiments at Camp Cory. Camp has meant so much to not only me but to so many other people that it always seemed shameful that we had no written history of such a special place. I have wanted to write a history of Camp Cory for many years. Deep down, I always knew it was beyond me. I lacked the focus, the patience and, most importantly, the skill for compiling such disparate sources of information. Camp Cory's history is not an easy thing to locate. There is no Wikipedia article (other than what Bo has created); there is no neatly organized file of historical documents from which to draw. Bo's task required an exhausting number of man-hours, and Bo did it all alone. It began during his time between college and one of his several graduate degrees, when Bo worked in the downtown Camp Cory office compiling the camp's history. He started with the mind-numbing task of meticulously mining all of the names from the Camp Cory culminaries. This included entering into spreadsheets the names, addresses and available biographic information of every camper and staff member who attended Camp Cory from 1922 until 1964 (the year the camp stopped publishing the culminaries due to cost constraints). Bo went through these thousands of names and cross-referenced names across different years. He slowly began to find people who attended camp for multiple years, people who were both campers and staff, people who worked their way up through the ranks of camp; he identified the early movers and shakers of the camp. Concurrently, he looked through all other available records. He read the corporate board minutes from the earliest years of the YMCA of Greater Rochester, he found early newspaper clippings that mentioned camp, he found cashed checks for registrations (one dating as early as 1893) and he even reviewed Lawrence Cory's regimental history in the stacks

of the University of Rochester library and read Weldon Hester's letters in the rare book collections of the same library. This is just the research of which I was aware. I believe Bo spent more hours researching more avenues than anyone will ever fully know, save Bo.

Of course, this is just his secondary research. Bo also became the go-to representative for camp whenever an alumnus stopped by and wanted to tour camp or had an interesting story to tell at camp's annual holiday party. Bo spent countless hours gleaning information from the people who lived through the events. Besides being a welcoming ear for all of Camp Cory's alumni, Bo also actively sought the people who had the knowledge to fill in the gaps in the camp's history. He interviewed former camp director Jerry Elliott, he would ask me to connect him with alumni of my brothers' generations and, through this networking, he began to slowly close the gaps in his knowledge.

I can only estimate the total number of hours that Bo must have invested in this project. It was definitely a labor of love, the positive benefits of which reach well beyond the pages of this book. Because of Bo, long-removed alumni are now reconnected with camp; because of Bo people like Fred Dugan have been able to locate and reconnect with old friends from forty years ago; and because of Bo there are now documents hanging in the Camp Cory summer office where alumni can come and find their names listed from years long past. Every summer from my office I watched as alumni came by and scanned the lists for their names; and when they eventually did find their names, their faces lit up with an excitement that's only familiar to anyone who's seen a camper on the first day of a session at Camp Cory.

It was during one such moment three or four years ago that I was reminded of Bo and his life jacket. Dave Ghidiu and I were reconnecting with an old friend who had been on staff in 1996. We were showing him the lists compiled by Bo and enjoying his excitement when he found his name on the wall and realized that he was now a permanent part of Camp Cory's written history. It was like the floodgates opened in his mind. He started to ask Dave and I about tetherball, roofball, stratego, Holy Man, "Charlie on the MTA," color wars, staff shows, special day and numerous other traditions, some of which had survived and some of which had been retired. He asked Dave and me if campers still made personalized tiller extensions for the K-boats and if the type and style of life jacket was still a status symbol among Maijgren campers (the orange behind-the-head type of course being the lowest). This sparked my memory about Bo and his odd life jacket. I hadn't thought about Bo and his

"special" life jacket in years. The next time I saw Bo, I told him the entire life jacket story: about how I didn't know who he was as a camper and about how I had always assumed his life jacket was some sort of special accommodation because he was too weak to support his own head. After he finished laughing at me, he explained to me that it was just the style of life jacket his mom happened to purchase for him. As it turned out, Bo eventually bought a replacement and donated the original life jacket to camp. Bo told me it was still in the yacht club, and of course we ran right down, found the jacket and had a good laugh (mostly at my expense). Whenever Bo and I would see someone using the jacket, we laughed just as hard as we did the first time I told him the story. (And yes, the life jacket is still used today by the Maijgren campers).

This is just one of the thousands of shared memories, laughs and friendships that Camp Cory has helped foster over the years. With over one hundred years of history and over one thousand campers some summers, Camp Cory has been the lynchpin in thousands of networks of friends, with hundreds of thousands of shared memories and laughs. Were that Bo could capture all of these relationships and good times in writing.

One final note: Other than my family, Camp Cory shaped who I am today more than any other person or place. As a naturally nostalgic person, I have always been saddened that the history of the beginnings of Camp Cory was becoming increasingly clouded as our alumni passed on, documents got lost and the passing of time dimmed everyone's recall. Every summer I would hear stories of the past. Alumni would visit camp and share names and dates, and I always wanted to capture this information, but day-to-day activities got in the way and I always put off the recording of the past until another day. I will forever be grateful to Bo for having the time, skill and love that were required to undertake this project.

Mark Dibble
1995, CIT / Junior Counselor
1996, Junior Counselor
1997, Senior Waterfront Director / Senior Counselor
1998–99, Maijgren Village Head
2000, Sailing Master
2001, Leadership Director / Program Director
2002, Program Director
2003–10, Camp Director

A NOTE ON THE TEXT

YMCA Camp Cory is an overnight and day camp located on Keuka Lake, just south of the Village of Penn Yan, New York. It was dedicated in 1921, although it was operating at that site in 1920 and had been operating elsewhere, under the name Camp Iola or without an official name, since 1892. It is a branch of the Rochester YMCA.

This is a collection of songs, stories, documents and narrative history relating to the camp. I didn't include several songs and stories that some may remember or cherish, either because they are too widespread among camps to reveal anything about the culture of Camp Cory in particular (e.g., "Boom Chicka Boom") or because they are copyrighted stories that have been published elsewhere. Reading the lyrics to songs is a poor substitute for singing, not least because several of the songs contained herein require hand and body motions. Nevertheless, I think this volume might be helpful to those who want to learn the songs of Camp Cory or who want to remember the songs as they were.

Similarly, reading the stories in this book is a poor substitute for hearing one of them at a campfire. The inflection, timing, extemporaneous asides and milieu of campfire storytelling are all missing when a person simply reads the stories in a book, perhaps curled up in a comfortable chair in his study next to a warm lamp. The stories here might be better understood as frameworks; a good storyteller will learn the elements of the story by reading them in this book but will then give the story a life of its own during

a campfire. Any story could obviously be told in different style, with different details present, absent, emphasized or deemphasized. "The H-Man," for example, was no doubt told differently in 1962, 1972 and 2002. Readers should understand that the versions of the songs and stories included in this collection are not the "official" versions. There are no "official" versions.

It would be impossible to acknowledge all of the individuals who helped me to create this collection. There were dozens of alumni, all giving varying amounts of information. Some alumni were able to tell me entire stories, and some alumni put me in touch with these storytellers. If you helped me: thank you. Those alumni who told me entire stories, and who therefore deserve especial thanks, are as follows: Jim Weller ("The H-Man"), George Parsons ("Rominy Gruen"), Dave Ghidiu ("Gillette" and "The Philadelphia Experiment") and Dave Knittel ("The Turtle Story"). Fred Dugan, Perry Jacobs, Scott Dasson, John Nelson, Art Haskins and Jerry Elliott provided additional details and put me in touch with the storytellers.

Documents, Songs and Stories from Camp Cory History

DOCUMENTS

IOLA: THE INFANT CAMP

The Rochester YMCA started in 1854 but failed shortly thereafter. It was reestablished in 1863, during the midst of the Civil War, but only lasted three more years. The City YMCA wasn't to see a permanent start until the 1870s. *See* Edward R. Foreman, *Centennial History of Rochester, New York: Volume III, Expansion* (Rochester: John P. Smith Company, 1933), 296, 303.

What follows is a very brief timeline of the early years of Rochester YMCA camping:

1892
The Rochester YMCA begins boys' camping programs on Lake Ontario. The camp originally consisted of two tents, fourteen boys, two men, a mess tent and a rowboat. The camp had no official name; as far as I can tell, it was referred to as "Rochester YMCA Camp" and the like.

1890s–1919
The Rochester YMCA Camp was, at some point around 1910, named Camp Iola, from an Indian word meaning "never discouraged." Camp Iola at first had only a two-week program and no permanent location. There were also seemingly three camps: one for younger boys, one for older boys and one for men (these latter two were sometimes located in the Thousand

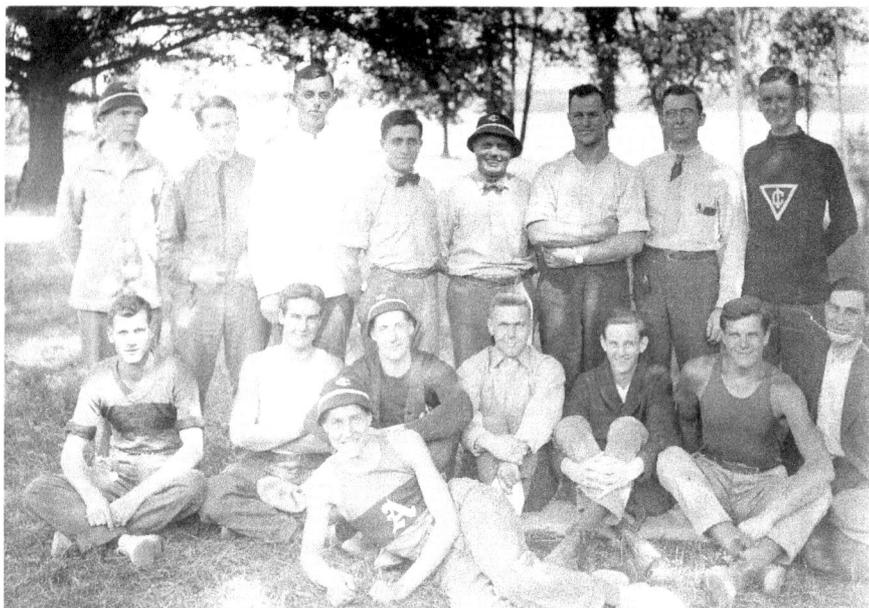

Boys at Camp Iola; note one boy wearing a shirt with the Camp Iola logo, *top right.*

Islands). Even in any given summer, the three camps could have been at different locations. The program eventually lengthened to incorporate more of the summer, and the camp moved to rented land on Eagle Island in Sodus Bay in 1893 and 1907 (and possibly the intervening years), to Canadice Lake in 1908 and to Tichenor Point on Canandaigua Lake in 1910. Here it stayed for several years. In 1918, the idea of a permanent Rochester YMCA camp was first suggested, although for some reason the Y was not able to purchase the desired land on Tichenor Point.

1920
The Rochester YMCA camp, which may or may not have still been named Iola, moved to a permanent location on Keuka Lake. Among the first buildings were the dining hall, a waterfront cottage and the Isabelle Cook Manual Training Building (now the office/store).

1921
The camp is dedicated as Camp Cory, after Lieutenant H. Lawrence Cory, a Rochester native who was killed during World War I near Thiaucourt,

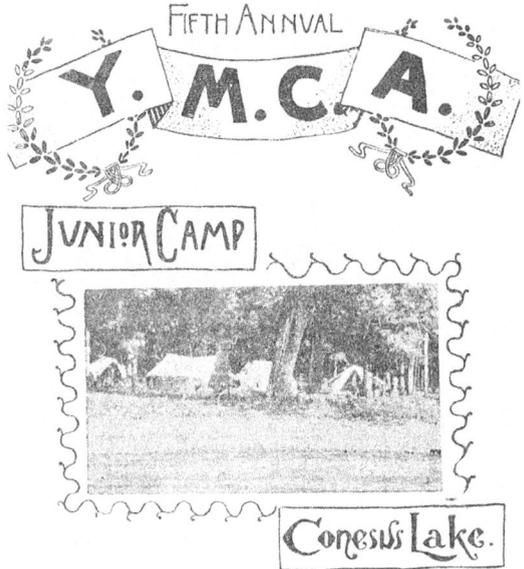

FIFTH ANNUAL Y.M.C.A. JUNIOR CAMP Conesus Lake. 1898

Right: An early camp brochure.

Below: A tent at Camp Iola, Canandaigua Lake, 1913.

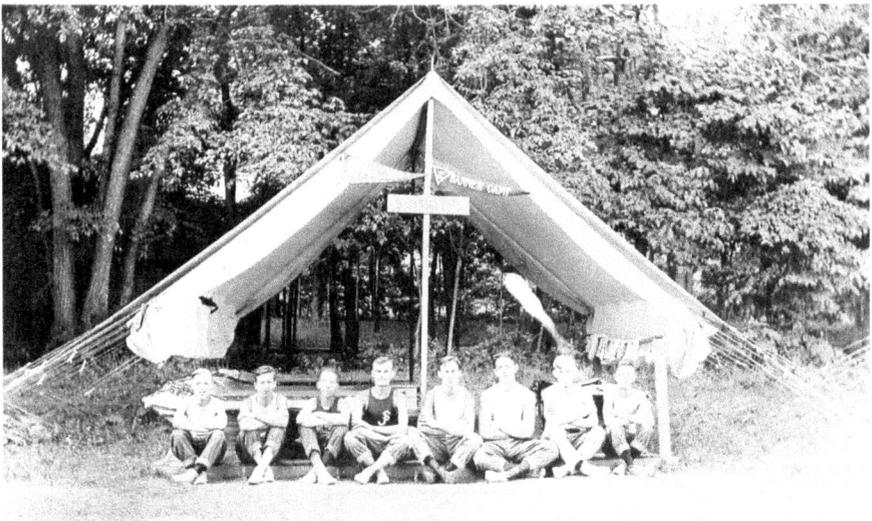

The tents at Camp Iola.

ROCHESTER DEMOCRAT

Purchase of Camp Site for Y. M. C. A. on Canandaigua Lake Shore Proposec

Tent Life at Tichenor's Point.

Iola's early attempts to obtain a permanent campsite were unsuccessful.

18

France. A horseshoe of tents in modern-day Senior Village was the sole area of camper housing. Staff stayed in a small cluster of tents at one end of the horseshoe. Among the first campers and staff members were Henry T. "Mike" Maijgren and Schuyler Wells, after whom two camp villages would later be named.

Colonel Moulthrop, the First Camp Director

Should a curious camp visitor allow his eyes to wander over the photos in the camp store, he would come to a singular realization: the history of Camp Cory predates any living soul. Indeed, our tradition in camping predates even the life of the eponymous Lieutenant H. Lawrence Cory. The Rochester YMCA began its camping tradition in 1892, when two leaders and fourteen boys spent two weeks on the shores of Lake Ontario. The "summer camp" was just one aspect of the "Boys' Work" program that encompassed much of the YMCA's mission in those days.

By 1910, camping had taken place at several locations, the most recent of which was Tichenor's Point, located a few miles south of Canandaigua on the west shore of Canandaigua Lake. Camp Iola, as it was then called, was not much more than rented tents on rented land; 146 boys attended the camp that first summer on Tichenor's Point.

A common sight at the camp in those days was "Colonel" Samuel Parker Moulthrop, who was sometimes referred to as the "Camp Commandant." Born in 1848, Moulthrop originally lived in Wisconsin, where the Menominee and Fox Indians still dwelt. He attempted to enlist in the army during the

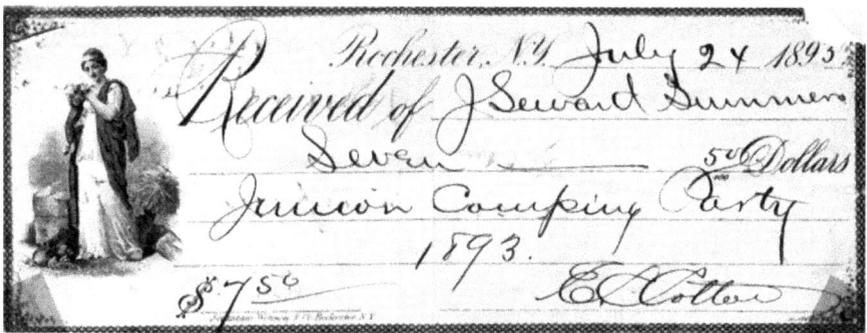

A check for camp from 1893. Note the cost.

JUNIOR CAMP

Tune: Auld Lang Syne.
Should I the joys of all the past
Forget and know no more;
The old camp life would ever last
And linger as of yore.

CHORUS
Potatoes on a piece of pork,
Black coffee in a pan;
With thumb and finger for a fork
Go beat it if you can.

The shining rills and creek so fair,
Where we the fish did hook;
And watch them patiently with care,
As we the same did cook.—CHO.

Let dogs delight to bark and bite,
And man the city prowl;
Say camp to me and out I light,
And loud the chorus howl.—CHO.

Rochester's Young Men.

Campers'
Reunion

March
Twelfth
1900

Junior
Department
Rochester
Young
Men's
Christian
Association

ELEVENTH SEASON

Young Men's Christian Association
Rochester, N. Y.
Boys' Department

CAMP

THE TENTS

LEROY ISLAND
Sodus Bay, N. Y.

July 1 to 15, 1903

For the members of the Y. M. C. A. Boys'
Department. Any boy between 12 and 17 years
old may join and have the privilege of the
Boys' Camp.

Above: A brochure from an early campers' reunion.

Left: Another early camp brochure.

Civil War, but men of import discovered the fourteen-year-old in their midst and whisked him back home.

He eventually became a teacher, and later a school principal, at several Rochester-area schools, although mainly No. 26 School. In the early twentieth century, he invented an adjustable desk to better accommodate adult evening classes; these desks were soon in demand nationwide.

In 1896, his "repute as an inspiring leader prompted Commander Charles Wood of the Veteran's Union to name him...with the honorary title of Colonel." He started with the YMCA in that same year, when he headed up the junior camp on Conesus Lake (there are no extant records about who ran the camp from 1892 to 1895). In 1910, Moulthrop helped form the first Rochester-area Boy Scout troop, along with Frank Gugelman (the Rochester YMCA boys' secretary and sometime director of summer camps).

It seems that throughout his teaching career, Moulthrop was obsessed with calisthenics and military maneuvers. Old Iola photos are replete with images of Moulthrop commanding campers in military formation. Colonel Moulthrop organized the horse battalion for the 1892 Memorial Day parade in Rochester, where President Benjamin Harrison was the guest of honor.

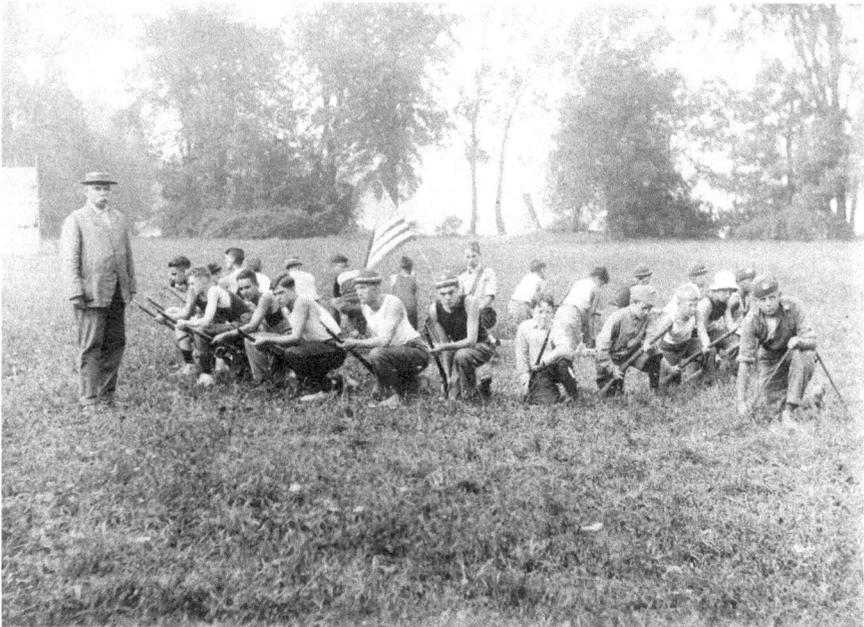

Colonel S.P. Moulthrop with campers.

A drill squad led by Colonel Moulthrop.

In all likelihood, Moulthrop came up with the name "Iola," an Indian word meaning "never discouraged." (The Iola Campus, now a cluster of semi-deserted buildings located at Westfall and E. Henrietta Roads, was also named by Moulthrop when it was originally created as a tuberculosis hospital, at his urging, in 1910.) In 1907, Colonel Moulthrop attended the first ever training seminar for camp directors, at Camp Dudley. There he instructed other camp directors in woodcraft and archaeology.

Colonel Moulthrop eventually retired in 1929, when he was eighty-one. He passed away in 1932. Though his duties as a school principal in Rochester had kept him busy, Colonel Moulthrop was a common sight at camp for some years after its permanent move to Keuka Lake. Indeed, the Cory-Iola tradition is greatly indebted to Moulthrop for his stalwart leadership, unerring volunteerism and intrinsic desire to contribute to the betterment of boys' camping.

See Blake McKelvy, City Historian, "Samuel Parker Moulthrop: Devoted Educator and Good Citizen," *Rochester History* 19, no. 2 (April 1957).

Documents, Songs and Stories from Camp Cory History

"The 'Bunch' at Camp Iola"

A Real Vacation For Real Boys

Right: A brochure for Camp Iola, 1917.

Below: "Nature study with Col. Moulthrop" at the Keuka site, circa 1920.

TWENTY-FIFTH SEASON

CAMP IOLA *for* **BOYS**

JUNE 28th to JULY 26th, 1917

Conducted by **Rochester Young Men's Christian Association**

CANANDAIGUA LAKE, N. Y.

A Letter from the Camp Director, 1905

September 7, 1905
Mr. F.F. Callyer,
156 Fifth Avenue,
New York, N.Y.

Dear Mr. Callyer:—
In reply to your inquiry regarding facts from our boys camp, would say that the Rochester Boys Camp was held from July 3rd to 21st at Seneca Point, Canandaigua Lake. It was in charge of C.A. McLaughlin, Boys' Work Director, assisted by Col. S.P. Moulthrop, Principal of No. 26 School, Rochester; also, six other assistant leaders.

We had 48 boy campers. The price of board, which included transportation, use of boats and a cot, was $12.00 for the eighteen days. Special educational features were introduced such as the study of geology, stereopticon lectures on birds and animals, Pennsylvania and the coal fields, Phillipine [sic] Islands. 17 Bible class sessions were held. 18 brief devotional meetings at the close of the day, and four religious meetings for the two Sundays. Fully 25 boys made decisions for the christian life.

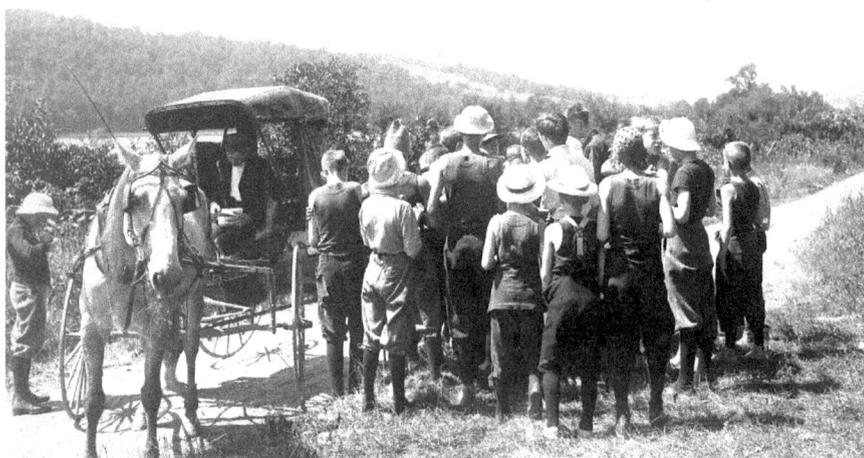

A carriage at Camp Iola.

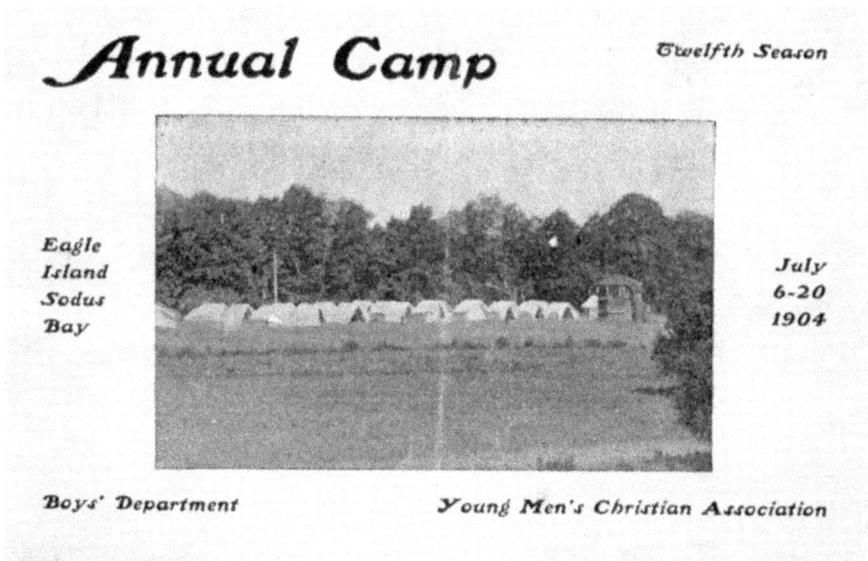

Annual Camp

Twelfth Season

Eagle
Island
Sodus
Bay

July
6-20
1904

Boys' Department Young Men's Christian Association

A brochure cover, 1904.

"Some of the problems"; the mess tent collapses at Iola.

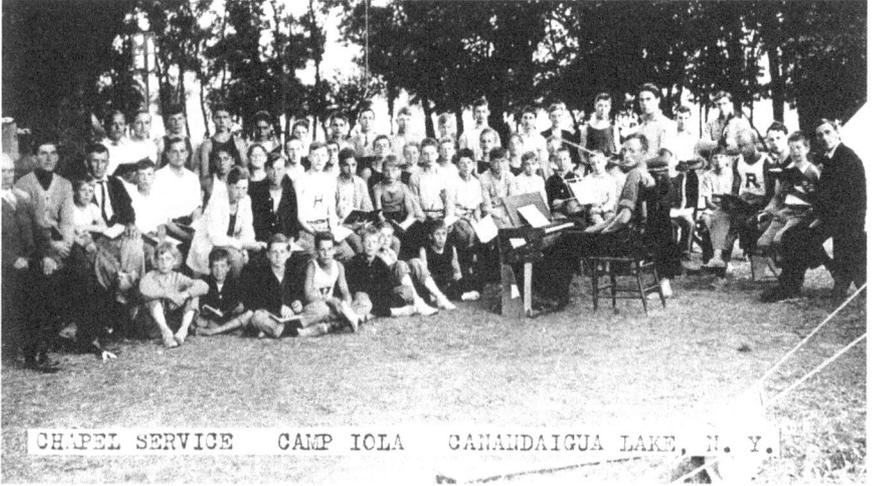

CHAPEL SERVICE CAMP IOLA CANANDAIGUA LAKE, N. Y.

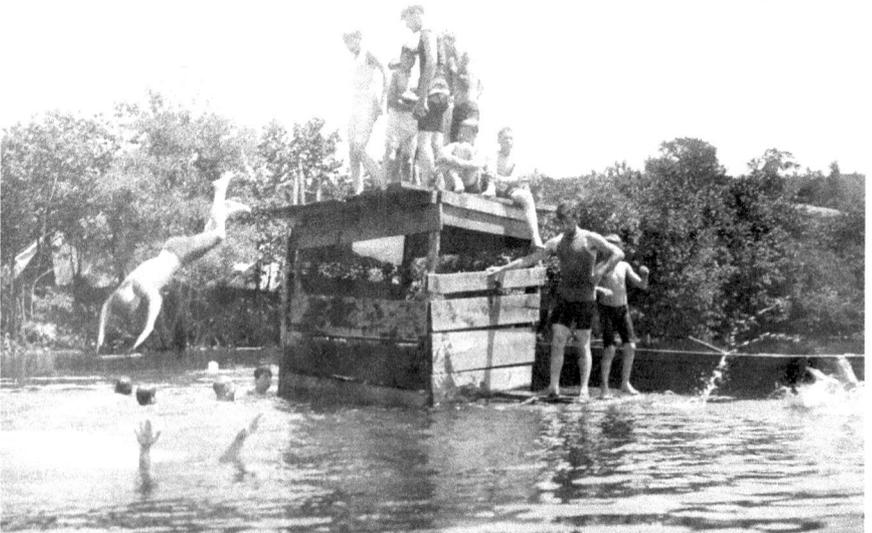

The Camp Iola diving tower. We've come a long way.

A second camp for older boys, which was limited to 16, was held at Rockport, Ontario, Ca., from July 24 to August 3. This location is in the heart of the Islands and made an exceptionally rare opportunity for fishing, boating and a general good time, and side trips were taken to Kingston, Ontario. A trip was made through Fort Henry, an old British

Fort, Kingston. A 50 mile trip among the Islands and the second searchlight trip for the evening was 25 miles.

This is a new feature of our Boys Department work, and proved a great success. It was especially for older boys, no boy under fifteen being allowed to go. The cost for the ten days, which included board, steamer en route both ways, use of row boats was $15.00.

The fall work for our boys is well under way. A Boys' Department Managing Committee of young business men have been appointed, which is to have full control of the boys work under the supervision of the Board of Directors. The budget has been increased from $1200 to $2400.

<div style="text-align: right;">*Cordially yours,*</div>

C.A. M^cLaughlin
Boys Work Director.

THE DEATH OF LAWRENCE CORY

Lawrence Cory was in the 3rd Brigade, 310th Infantry Regiment of the 78th Infantry Division during World War I. The 78th Infantry Division of the United States Army was activated on August 23, 1917 at Camp Dix, New Jersey. It consisted of four Infantry Regiments—the 309th, 310th, 311th, and 312th, and three Artillery Regiments—the 307th, 308th and 309th.

The Division was originally allocated to New York and northern Pennsylvania in the National Army plan. While the HQ of the 78th Division was activated in August, with the first draftees arriving in September, it was not fully active until early 1918. It was transported to France in May and June of 1918.

In France, during the summer and fall of 1918, it was the "point of the wedge" of the final offensive that knocked out Germany. The 78th was in three major campaigns during World War I—Meuse-Argonne, St. Mihiel, and Lorraine. Demobilization at the end of the war took place in June 1919.

HQ, 78th Division was returned to the Organized Reserve List, and reallocated to the Second U.S. Corps in Spring of 1921, with its area of allocation changed to New Jersey and Delaware.

—From the website of the 78th Division

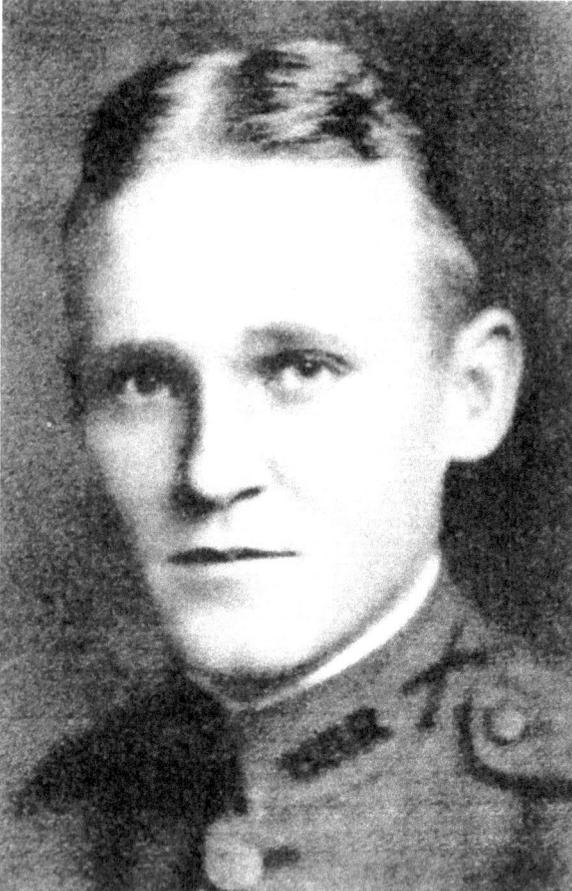

Lieutenant H. Lawrence Cory.

"The Death of Lawrence Cory"

Harvey Lawrence Cory was born on October 18, 1896, in Rochester, New York. He attended Ridgefield Prep School in New Jersey and entered Princeton University as a member of the class of 1917. In April of that year, along with some classmates, he left school to attend officer training in Plattsburg, New York. He was commissioned a second lieutenant in due time, and he, along with his friends, received his Princeton diploma in absentia.

He trained at Camp Dix, in New Jersey, "amid a haze of unfinished buildings, hot sun and sand." Cory was assigned to the Machine Gun Company, 3rd Battalion, 310th Infantry Regiment, 78th Division, under the command of Captain Kaliska, who was his direct superior. On June 9, 1918, after nearly a year of training and transport, the regiment arrived

in Calais, France. Soon after this, their specialized combat training began under the tutelage of British war veterans. An advance party from the 310th was sent out to the front lines in order to gain valuable combat experience, and the first fatality was suffered. The regimental historian writes, "From that moment on a deeper spirit permeated the regiment. A war which had seemed always far and remote became startlingly near despite the pleasant fields of France surrounding our area." By mid-July, the regiment was on the move again, this time toward the American sector, where they could eventually eat American rations and suffer American habits. For the time being, however, the regiment camped among the huge French manure piles.

By September 5–6, 1918, Cory and the rest of the 310th marched through the woods closer and closer to the front lines. "Rain fell continuously, transforming the roads into seas of mud, churned into a plastic mass, ankle deep, by the transport which preceded us." On the tenth: "Suddenly as the column crawled, snakelike, over the crest of a hill, the sky line, invisible until then, was illuminated in one continuous flash of flame that leaped from left to right as far as the eye could see." As they advanced farther the next day, "shell craters were everywhere; abandoned transport lined the road." On the night of the fifteenth, Cory's regiment relieved a regiment of marines who had been struggling to hold together a broken line. Cory spent the night in the trenches about two miles north of Thiaucourt, near the Belgian border. On the night of the sixteenth, sixty Germans attacked the front lines—where Cory and his Machine Gun Company were stationed—and were repulsed. A shallow ravine led directly from the American front lines to the German strong point at the Mon Plaisir Ferme (Farmhouse), located eight hundred yards distant. Officer-led patrols went out every night in order to harass the Germans and map out no-man's land, and one patrol even drove the Boche (Germans) out of two of their machine gun nests at the wire fence surrounding Mon Plaisir.

Past noon on September 21, Colonel Babcock, the regimental commander, outlined an attack plan for that night that required the 3rd Battalion and two platoons from Machine Gun Company to hold the line one hundred yards past the farm for the span of twenty minutes. During this time, engineers would move in and demolish the buildings. The two machine gun sections were to take up the flanks on either side of the attack and would both defend the attackers and remain behind to defend the retreat from a German counterattack. At midnight, the soldiers waited for the order to go

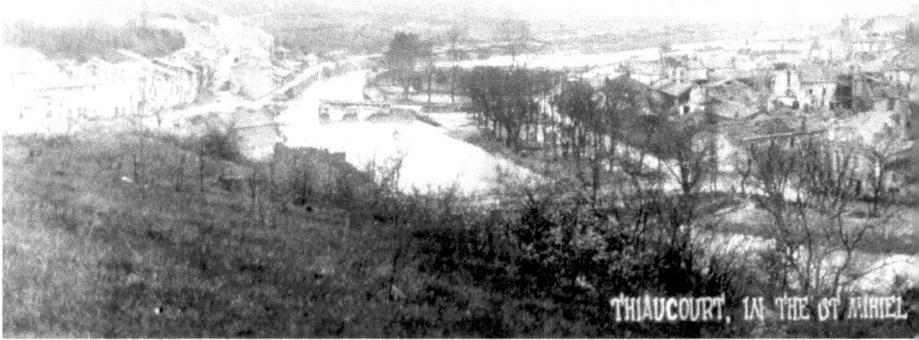

Thiaucourt, France, the village near which Lieutenant Lawrence Cory was killed during World War I. *Courtesy of the Library of Congress.*

over the top of the trench, but alas, no engineers had arrived. The attacking force waited until 1:00 a.m. and then decided to go forward with the attack anyway. "Instantly, the sky was ablaze with the German flares and rockets." After twenty minutes, the Germans had been pushed from their positions, and the 3rd Battalion held its ground for a further twenty minutes, following orders despite the failure of the engineers.

By 1:40 a.m., the signal to withdraw was sounded, but Boche machine guns fired from the flanks. The American machine gun companies had to fire upon these nests in order to protect the doughboy withdrawal. Cory and his men repositioned themselves in a decidedly more dangerous position in order to protect the retreat. By the time the retreat was completed, it became clear that Lieutenant Cory had gone missing, along with twenty-nine of his men. Lieutenant Flynn, who commanded the other section of machine guns, went out with a sergeant in search of Cory and stayed out until dawn, to no avail. Flynn told the company commander, who went out with the first sergeant in the broad daylight to look for Lieutenant Cory; he, too, was unsuccessful.

Five officers and seventy-two men were wounded in the assault, and sixteen were killed. Patrols sent out in search of Lieutenant Cory the next several nights proved fruitless, and the Americans continued scheduling attacks in order to deprive the Germans of the "feeling of ownership and control of the ground." The 310th yearned for a mass attack, but instead the 89th Regiment relieved them on October 4.

In December, several American prisoners returned from behind German lines, and they had this story to tell: During the American withdrawal from

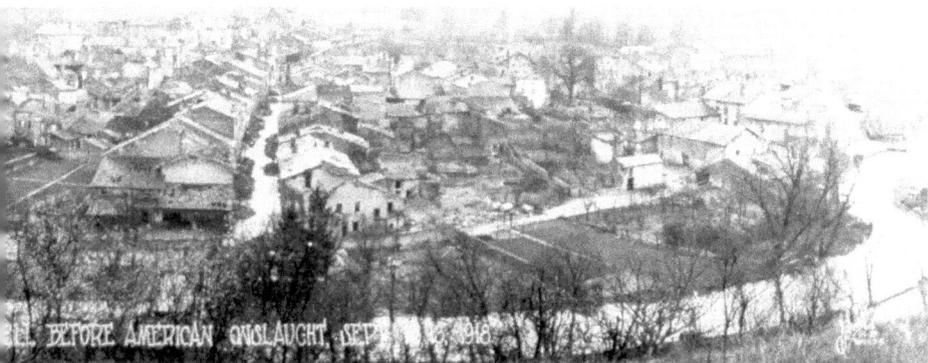

Mon Plaisir, Lieutenant Cory and his men had encountered a large number of American soldiers who were confused as to the direction of the retreat. Cory helped them along the way and hid his thirteen men in a shell crater while they passed. A little while after this, Cory saw silhouettes of more men moving along not far from his position. In order to ensure that he did not accidentally open fire upon his comrades, Cory himself went out to reconnoiter. The men, it turned out, were Germans, and they immediately fired on Lieutenant Cory, hitting him in the stomach. When his men went out to help him, the Boche summarily captured them. One soldier was allowed to wait the night with Lieutenant Cory who, by the morning, was in such sad shape that he was not expected to live much longer.

His parents would not receive an official death notice until 1920, at which time they donated a large sum—either land or money—to the Rochester YMCA in order to immortalize the name of their son. He is also memorialized at the Third Presbyterian Church at the corner of East Avenue and Meigs Street in Rochester, New York, and on the fireplace at Camp Choconut in Friendsville, Pennsylvania—where he once attended camp.

NOTES:
Most of the information I used to write "The Death of Lawrence Cory" was in the letters included below, on the 78th Division's website or in Raymond L. Thompson, *A History of the Three Hundred Tenth Infantry, Seventy-Eighth Division, U.S.A., 1917–1919* (Association of the 310th Infantry, 1919).

Letters Regarding Lawrence Cory

Machine Gun Company
310 Infantry.
24 December 1918.

Sir,

It has seemed the thing to do to obtain more definite information of your son and my brother officer before telling his family the known circumstances of his capture. Since his capture the night of 22ⁿᵈ September, Lieut. John Case, Lieut. Chandler Knight, and myself, successively commanding the company, have tried to get news of his whereabouts thru the Divisional Red Cross, the Red Cross hqs. at Paris, and the German Red Cross—but with no success. The last word about him has just come from returned prisoners, men of his own platoon who were taken with him.

I think, then, it may give you some small comfort to know what little news I have.

A battalion night raid was ordered the night of 22 Sept. on the front held by our regiment, to attack and destroy a fortified farm—the Mon Plaisir Ferme—some two miles north of Thiaucourt, near the Moselle river, in the Department of Meurthe-et-Moselle. The 3ʳᵈ battalion was detailed for the raid, and was supported by a platoon of machine guns, one section of guns supporting the left flank of the attack, the other section the right flank. The work for the machine guns was particularly dangerous, for not only were they to support the attack, they were to stay out after the infantry had returned to prevent a boche counter-attack. Lieut. Cory had the left section, two guns and 13 men, Lieut. Flynn the right section.

They went over the top at one a.m. The less said about the part played by the infantry and the engineers, the better. About half past two Flynn came back with what was left of his section, placed his men and guns in their positions in our trenches, and walked over to see if Cory had returned. When he found they had not, he took a sergeant with him and went out to look for them, going as far as the boche wire and staying out until daybreak. It was so dangerous and the enemy fire so intense, he had recommended a D.S.C. for it. There was no luck, not a trace of the missing men on the ground they had gone over. On his return Flynn reported to John Case, then commanding the company, and John, taking the first sergeant with him, set

out to look for them, going right to the boche wire by daylight, at the risk of almost certain death or capture; there were no traces.

The Red Cross was notified, but the first news I have had was last week, when one of the men lost that night reported back to the company. Two more have since come in. The story they tell is this.

Your son was leading them thru the German wire when a lot of our infantry came milling along, very confused, not knowing their direction. In order to keep his men together, Lawrence took his men into a large shell hole, until the ground was clear of our men so he could fire—for there were three boche machine guns bothering them.

While they were in the shell hole, Lawrence saw some men moving thru the wire. Not knowing who they were, he went out to see. It was a party of Germans, trying to start a counter-attack. They were not more than twenty paces from him, so they called for him to halt, at the same time firing at him with a rifle. He fell. His men—they were unarmed—ran out to him, and they were all taken prisoners by the boches. He was shot thru the stomach, the bullet apparently striking his spine, for he could not move his legs. The Germans had his men carry him to their first-aid dugout, and let one of them stay with him over night. In the morning the soldier was compelled to leave him to go to a prisoners cage. At that time he felt the lieutenant could live but a short time.

Unless I do hear from the Red Cross, if I can get a leave of absence, I am going to that part of the St. Mehiel sector to see if I can find his grave.

I cannot sympathize with you; it is too useless. Your son died a man's death in a man's way. When he went out that night, he did not expect to return. He went willingly—and we loved him.

[Signed] *AVRA M. W[A????]*.

2nd Lt. 310th Inf. M.G. Co.
Commanding.

[indecipherable print along top: "…Officer of 310th… October…191?"]

Several times during these past hours, I have started writing this letter but without success. Undoubtedly everyone at home probably knows of the

sudden disappearance of "Pop" Cory. It happened some days ago but the Colonel, continually holding on to the hope that he would return, refused to allow anyone to give the details. Now Pop has been officially reported as missing, thus making what I have to say entirely legal. In fact, the Colonel gave me verbal permission to tell what I know. At that same time I hardly wish to make my letter [?"and etc."]—*that is what caused me to start writing several times—trying to make up my mind as to whether I would mention it at all. But I realize that you, knowing Pop quite well, will probably be interested and at the same time you may as well have first hand information, being in a position to furnish it as I am.*

On Sept. 22nd, one of our Battalions executed a local raid against an enemy strongpoint opposite our sector. "Pop", Lieut. in our machine gun company, was detailed to conduct flanking fire to protect our men. He, with his platoon and guns, followed the first wave, offering resistance at any sign of energy on the part of the enemy machine guns. After our troops had reached the objective, Pop placed his guns to protect their withdrawal—firing continually at all Huns that appeared. After the withdrawal had been about half completed, he ordered his guns to retire. Again the Huns opened fire and Pop, to protect our men from them, replaced his guns and fired until our men were under cover. He was never seen again by any of our troops. The next night, the Colonel organized a party to search the entire area for some trace of Pop and his men but nothing was found altho [sic] *our men were out thruout* [sic] *the entire night doing their best. Every effort was made to locate him but <u>nothing</u> was found. There is every reason in the world to believe that he was captured with his entire platoon. In that case he is out of the war for good. If he had been killed, he would have undoubtedly been picked up, it being impossible for the Germans to pick him up because all of the ground covered by the raid is continually under observation from our lines.*

That, dearest, is about all that I can say—the actual facts being as I have stated them. All of us feel very sad about the affair—and particularly myself because I have known Pop for quite some time. He was one of the most popular officers we had both among ourselves and among the men. In replacing his guns as he did, the result could hardly have been avoided. That move done <u>purely</u> to protect our soldiers in their withdrawal, cost him either his freedom or his life—I hope with all my heart that it was the former. He <u>must</u> have realized what it would mean—remaining in no man's land as

he did—and he disappeared, or died a hero. It produced a profound effect upon me—his loss and the loss of many of my other friends too. Still it is war and I suppose such things must be expected but it is anything but easy.

<center>***</center>

The American Red Cross
National Headquarters
Washington, D.C.
[more names along either side of letterhead]
Bureau of Communication
W.R. Castle, Jr., Director

<div align="right">

January 18, 1919.

</div>

My dear Mr. Cory:
We learn from the other side under date of December 2ⁿᵈ in reply to our cable, that every possible means is being used to investigate the facts about Lt. Harvey L. Cory, Machine Gun Company, 310ᵗʰ Infantry, who was reported missing in action on September 22ⁿᵈ, and we will write to you again as soon as we receive any information.

<div align="right">

Very sincerely yours,

</div>

Wm R. Castle, Jr.
*LP.N*ALC*
Mr. Harvey E. Cory
1270 East Avenue
Rochester, N.Y.

<center>***</center>

War Department.
The Adjutant General's Office,
Washington,

January 21, 1919
In reply 201(Cory, Harvey)CD
refer to
Harvey E. Cory

The Alling & Cory Co.
Rochester, N.Y.

Sir:
I regret to advise that this office has received no further information concerning 2ⁿᵈ Lieutenant Harvey Cory, Machine Gun Company, 310ᵗʰ Infantry, than that he was reported missing in action since September 22, 1918.

Every effort is being made by the Commander abroad to locate men reported missing, and lists are being received from him daily of numbers of such men who have been located, and you will be notified immediately by telegraph should the above name be in any of these lists.

In the meantime, it is suggested that you may obtain some information by writing to:
Bureau of Communications,
American Red Cross,
Washington, D.C.

Very respectfully,
[signature indecipherable]
Adjutant General.
LMS
[?B]

<p style="text-align:center">***</p>

[except for the name and location of the base, this letter is entirely hand-written]

A.P.O. 716, Camp Pontanezen
Brest, France
Jan 22 1919

Dear Mr. Cory—

A letter from home received this afternoon told of Lawrence's sad death and was the first information that has come to me. I have tried to find out about him from every officer from the 78th Division who has come thru here but none would tell me more than he was missing and that has been published.

Please accept my deepest sympathy. I know how much I will miss him and can realize in a [?measure] how very much more the loss means to you and Mrs. Cory. His pleasing personality and his congenial temperament together with the future ahead of one of his ability, marks his [?absence] the stronger felt by us all.

Officers returning from the front thru this base bring many heart wrenching tales and many of my classmates from Company Seven [?Madison] Barracks were killed in the big push.

Lawrence, no doubt, had his surplus baggage stored in Paris. Lieut. Hunting left his [?with] Hollinguen + Cie, 38 Rue de Proveudeu and it is quite likely that Lawrence did the same. Hunting can probably tell you how best to handle it. Should there be any way in which I could assist in this or any other way, please let me know. It is doubtful if I can get to Paris before going home should my discharge be approved at G.H.Q. The Commanding General here has forwarded it "approved." Should I be in France after March fifteenth it is quite possible that I will go thru Paris on leave.

With my best regards to all and my deepest sympathy,

Yours very truly,
Howard K. Weed.

[outside of envelope:]
Capt. Howard K. Weed, Q.M.C. *Officers Mail*
A.P.O. 716, Camp Pontanezen. *[Stamped Rochester, NY*
Amer.EXP.Forces. *East Ave Sta Feb 6 11:30 AM]*

Mr. H. E. Cory
c/o The Alling + Cory Co.
Rochester N.Y.
Howard K. Weed. General Delivery U.S.A.
Los Angeles, Calif.
Censored O.K.
Capt. Q.M.C.U.S.A.

```
/ Capt.Howard K.Weed,Q.M.C.
  A.P.O.716,Camp Pontanezen.
  Amer.EXP.Forces.
```

Officers Mail.

```
Censored O.K.
Howard K. Weed.
Capt.Q.M.C.U.S.A.
```

The handwritten envelope in which one of the letters was placed.

<p style="text-align:center">***</p>

War Department
The Adjutant General's Office
Washington
AG 201 (Cory, H. Lawrence) WW *August 12, 1920*
Mr. Harvey E. Cory
1270 East Avenue,
Rochester, N.Y.

Dear Sir:
I deeply regret to inform you that upon investigation it has been ascertained by the War Department that Lieutenant H. Lawrence Cory, Machine Gun Company, 310th Infantry, who was previously reported missing in action since September 22, 1918, then presumed to be dead, was killed in action September 22, 1918. A notation to that effect has been placed upon the official records.

Notification of the death of this soldier has this date been forwarded to the Director, Bureau of War Risk Insurance, Washington, D.C.

For information concerning his insurance and arrears of pay due, you should apply as follows:
Concerning insurance to:
Director, Bureau of War Risk Insurance,
Treasury Department, Washington, D.C.
Concerning arrears of pay to:
The Auditor for the War Department,
Treasury Department, Washington, D.C.
In no case is it necessary to employ the services of an attorney or claim agent.
This office extends its deepest sympathy in your loss.
Very Respectfully,
P C Harris [?]
The Adjutant General.
Per: ML[?] [?K or R]

EARLY CAMP CORY DOCUMENTS

Below are transcriptions of several documents relating to Camp Cory's first decade.

REPORT OF CITY BOYS' WORK DEPARTMENT
September 21, 1920
Board of Directors,
Young Men's Christian Association,
Rochester, N.Y.

Gentlemen:
The greater part of the time of the City Boys' Work Department during the summer was given over to the establishing and conducting of the new camp at Keuka Lake. An advance party, consisting of 12 husky older boys and young men, arrived on the morning of June 21st and spent ten days in making tennis courts, moving buildings, digging trenches, laying pipe, constructing docks, moving platforms, pitching tents, erecting bridges, building cots and doing numerous other jobs of a similar nature. The result of the ten days' effort was a camp entirely ready for operation when 91 boys arrived on July 1st.

Average attendance:-First week............95,
Second week.....102,
Third week........111,
Fourth week......109,
Fifth week.........107,
Sixth week.........119,
Seventh week....114.

After the close of the seventh week, on August 19th, the regular campers left at 12 o'clock and at 2 o'clock 94 underprivileged boys, selected by the Social Welfare League, arrived. This group, together with 20 leaders, made a camp of 114, which continued for nine days.

The average attendance of boys per week was 110 for the 8½ weeks, and 325 was the total attendance.

CAMP ATTENDANCE

Campers Enrolled............ 199
Directors and Leaders....... 26

Total 225

WEEKLY ATTENDANCE

1st Week................. 75
2d Week 96
3d Week 109
4th Week 116
5th Week 120
6th Week 123
7th Week 119
8th Week 107
Average 108

SEASON'S TENT INSPECTION

No. 7 976 Points
No. 6 964 Points
No. 8 954 Points
No. 2 951 Points

No. 7Had Banner 12 Times
No. 10.........Had Banner 7 Times
Nos. 5 and 6....Had Banner 6 Times

CLOSING BANQUET

Rochester "Y" Camp For Boys

ON

KEUKA LAKE. N. Y.

TUESDAY. AUGUST 23d, 1921.

Cover of the year-end banquet program, 1921. The bridge is behind modern-day S-10. Note the dining hall in the background.

MENU

Tomato Bisque

Saltines · · · · · Olives

———————

Roast Duck with Dressing

Apple Sauce

Mashed Potatoes · · · Corn on the Cob

Celery · · · Jelly

Rolls

———————

Tomato Salad

Banana Split · · · · Cake

———————

Lemonade

PROGRAM

"Passing Remarks" by Camp Representatives

No. 2—"Gord" Grant.
No. 7—"Clarkie" Oviatt.
No. 4—"Gil" Hathaway.
No. 3—"Alfie" Zelter.
No. 10—"Rus" Kantor.
No. 5—"Morey" Forman.
No. 12—"Bob" Kunow.
No. 1—"Shrimp" Whipple.
No. 9—"Cliff" Stover.
No. 6—"Buster" Rogers.
No. 11—"Steve" Leavenworth.
No. 8—"Don" Hogue.

"The Junior Leaders" · · "Wink" Brown

"The Leaders" · · · "Jerry" Fisher

"A Few Remarks" · · Guests and Others

The interior to the 1921 banquet program. Clark Oviatt led Tent 7.

On August 28th 55 men arrived in camp, remaining until September 6th, making the total attendance of men and boys in camp during the summer months 380.

The day that the men left 72 members of the Penn Yan Chamber of Commerce held their annual picnic and outing at the camp, closing with a dinner at six o'clock and a business meeting following. We were glad to have this opportunity of entertaining the business men of Penn Yan, who had done so much during the previous weeks and months to help make our first camp on Keuka Lake a success.

The outstanding feature of the camp was its newness and the excellent manner in which the site, the lodge, the location and the entire camp have met the needs of the groups which used them.

Many persons visited the camp. Among those who came and made a real contribution and helped to feature the first summer's camp was the French Delegation of "Y" Workers; Alton B. Packard, Chautauqua cartoonist and lecturer; H.C. Beckman, director of Camp Dudley and camp expert of the State

CAMP CORY PROGRAM

Dailey Except Sunday.

6:45 A. M.	Reveille -- All out.	
6:50 "	Setting Up Exercises.	
6:55 "	Flag Raising - All stand at attention.	
6:58 "	Morning Dip - All are urged to "dip".	
7:15 "	Get blankets out for airing.	
7:30 "	Breakfast call.	
7:35 "	Chapel Service in Dining Hall.	
7:45 "	Breakfast.	
8:15 "	Leaders' Meeting.	
8:15 "	Get Tents in order, and ready for inspection.	
9:00 "	Tent Inspection.	
9:00 "	Squad duties for the tent assigned.	
9:30 "	Instruction groups.	(Nature Study -
		(First Aid -
11:30 "	Swimming.	(Radio -
		(Shop work -
12:30 P.M.	Dinner.	(Manual Training -
1:15 "	Store opens - Distribution of mail.	
1:30 "	Rest Hour.	
2:30 "	Afternoon Games.	
4:30 "	Afternoon Swim.	
6:00 "	Supper.	
7:00 "	Campus Games (Except Wednesday evening, when every boy must write a letter home.)	
8:00 "	Meetings -- Camp Fires, Entertainments.	
9:00 "	"Tatoo" - All in tents.	
9:10 "	Second Call - Tent Vespers - Quiet must prevail.	
9:20 "	"Taps" - Lights Out - All quiet.	

1923 daily schedule.

Documents, Songs and Stories from Camp Cory History

CAMP CORY

++++++ SUNDAY PROGRAM ++++++

7:30 A. M.	Reveille - All out.
7:35 "	Setting Up Exercises.
7:40 "	Flag Raising
7:45 "	Morning Dip.
8:10 "	Blankets out for airing.
8:30 "	Breakfast Call.
8:35 "	Chapel Service in Dining Hall.
8:45 "	Breakfast.
9:15 "	Leaders' Meeting.
9:15 "	Get Tents in order, for inspection.
10:15 "	Inspection.
10:15 "	Squad duties.
11:00 "	Sunday Morning Wash.
12:00 "	Call for Church Service.
12:15 "	Church Service in Chapel.
1:15 "	Call for Dinner.
1:30 "	Dinner.
2:15 "	Meeting of Junior Leaders.
2:15 "	Rest Hour - Write a letter home.
3:30 "	Group hikes, stories, nature study.
5:00 "	Short Swim.
6:00 "	Supper
7:30 "	Evening Song Service.
9:00 "	Tatoo Call.
9:10 "	Tent Vespers.
9:20 "	Taps - All Lights out and quiet.

1923 Sunday schedule.

Committee; President Sibley of the Board of Directors; Edwin Allen Stabbins, Chairman of the City Boys' Work Committee; Edward Harris, Chairman of the Camp Committee; and other members of our Board of Directors and our General Secretary; Rev. F.G. Reynolds of the Parsells Avenue Baptist Church; Rev. W. [?] A.R. Goodwin, D.D., St. Paul's Episcopal; Rev. Paul Moore Strayer of the Third Presbyterian; Rev. F.C. Boynton of the General Theological Seminary of New York City; and the pastors of Penn Yan.

A word of appreciation must be said for the work done by the twenty-five volunteer leaders who contributed to the success of the camp. These leaders ranged in age from older high school boys at the age of 17 to college men and younger business men, up to Colonel Moulthrop, who is over three score years young, not old.

Program
A fourfold program, contributing toward the development of the physical, social, moral and religious life of the boys, was conducted, which provided for classes, games, contests of all sorts, overnight hikes, trips and religious meetings, the outstanding trip probably being the journey of the entire camp to [here the page ends]

Penn Yan Democrat
Vol. 112, No. 3: May 10ᵗʰ, 1929
Completing New Building

——

Camp Cory to Entertain Junior Boys

——

Work on the new building at Camp Cory, the Y.M.C.A. camp on Lake Keuka, which is to be given over entirely to junior boys, under 12 years, is fast nearing completion. The work, which must be completed by July 1ˢᵗ, is being done by Brainard Brothers, Inc., contractors of this village, which firm also erected all buildings at Camp Pioneer, the Boy Scout camp on Seneca Lake.

The main building, or assembly hall, is 60x30, with a 12-foot porch. The building will consist of one large room to run the length of the building; at the eastern end there will be a huge cobblestone fireplace. The railings of the large porch, which extends on two sides of the building, will have boat slides to the lake, and the railings and posts will be rustic, being made of the swamp elms which grew on the site where the building is being erected. There are 15 windows in the hall, which is built of white pine, with special siding.

In addition to the large hall, there are several smaller buildings being erected, to be known as tent houses. These will house the boys and will have permanent floors and roofs, with siding up about three feet from the floor, the remainder to be canvas. Each tent house will be occupied by eight boys.

A handsome one-story cottage is being built for Dougall [sic] Young, of Rochester, camp director. This cottage is 35x35, including a porch with one large living room and cobblestone fireplace at the south or highway end, kitchen, breakfast room, with built-in tables and seats, two bedrooms, fully equipped bath. The porch will have rustic trim, posts and railings being of swamp elm with the bark on.

All buildings will be wired for electricity, Clay F. Kinyoun being the contractor. The camp director's cottage will have hot and cold water, the heat being furnished by "bottled" gas, which is also used in the large buildings at the other side of the camp which were built some six years ago.

The cost of building, plumbing, wiring and all equipment will be approximately $10,000.

The grading of the approach to the buildings will be done by Henry Carey, of Penn Yan.

<div align="center">

✳✳✳

</div>

A Camp Newspaper Blurb about the Water Slide

Probably the most noticeable feature in camp, outside of the new boathouse, is the slide. Camp Iola used to have a chute, but that is not to be compared to the new Cory thriller. The slide is an experiment and was designed by Mr. Young and Mr. Brown in cooperation with Mr. Terwilliger, the carpenter who built the lodge and the new boathouse.

A HISTORY OF CAMP CORY

" C A M P C O R Y C L I P S "

Published weekly by Camp Lawrence Cory
Keuka Lake, Penn Yan, N. Y.

- -

No. 1 July 11, 1929 37th Season

- -

Editor-in-chief Munro Will
Business Manager. . . . Elbert A. Ellis

Associate Editors

Social Activities . . . Robert M. Hennessy
Athletics Roger Vickery
Tent News Elbert A. Ellis
Exchanges Elbert A. Ellis
Humor Gordon Meade
Junior Camp Section . . Leland Stevens

- -

Contributors to this Issue

1. "Mike" Maigren
2. "Bob" Merklinger
3. "Bill" Heiber
4. "Bob" Shannon
5. "Chris" Smith
6. "Bert" Standing

- -

Contents

1. Season of 1929 - Editorial
2. Inspection - Editorial
3. 1929 Faculty
4. Leaders
5. Junior Leaders
6. From the Outside Looking In
7. First Week in Camp
8. Athletics in Cory This year
9. Track Meet
10. Leader-Camper Baseball
11. Leader-Camper Volleyball

12. Library Notice
13. Fourth Celebration
14. Leader's Stunt Night
15. The Tower Party
16. Saturday Stunt Night
17. Tent News
18. Six Years Ago, "This Week in Cory"
19. Leader News
20. "Y's" Cracks
21. Cartoons
22. Junior Camp Section

- -

SEASON OF 1929

With the influx of 150 campers Monday, July 1, the 37th season of Camp Cory made its official opening. Enthusiasm and interest ran high with the prospect of a number of changes and improvements in camp equipment and activities besides just the good old time to be had. This year marks the inauguration of the Junior Camp taking boys from 9 to 12 years of age. This situated on a large plot of ground adjoining the old camp, is entirely separate from the Senior camp except in one respect. Campers from both sides eat in the same hall. Instead of holding fifteen tables as formerly the mess hall when full to accommodate the junior campers will have 21 tables. In Rochester during the last year a drive has been conducted by the Rochester Y.M.C.A. for money to build this new camp. With the money collected a large boathouse and recreation hall has been built, also seven small cabins for the juniors and a new cottage for Mr. Young and his family during the summer. As part of the new sanitary system here at

A cover of *Cory Clips*, an old camp newspaper.

"Gillie" Hathaway initiated the slide one morning during the advance party. The morning dew was on the slide and "Gillie" took a mean flip when he reached the bottom.

—from the July 6, 1923 issue of *Camp Cory Clips*, reprinted July 11, 1929.

46

SONGS

"The Call to Camp"
(From the 1913 Camp Iola brochure)
Come, boys, into the open!
Break away from the din of the town
And camp on the shore of Lake Canandaigua
The place to get healthy and brown,
In the great out-of-doors that calls you
Thru the woods, where boys have tramped
That have echoed with song and laughter
By those who at Iola have camped.

Come, boys, into the open!
And answer that call of desire
To be back again close to nature
And enjoy the roaring camp fire,
Around which the boys are seated
With stories and remembrances gone o'er
As the fire burns down to ashes
On Lake Canandaigua's shore.

"Granny's in the Cellar"
Granny's in the cellar
Lordy can't you smell her
Baking biscuits on her darned old dirty stove

From her eye a piece of matter
Drips down into the batter
And she whistles as the [SNIFF] goes down her nose

Down her nose!
Down her nose!
And she whistles as the [SNIFF] goes down her nose

"Here Comes the King"
(Traditionally sung by Maijgren Village at the last dinner of a two-week session. The village would wait outside until the meal was just about to start and would then burst in, clad in lifejackets and sunglasses, singing…)
Here comes the King, here comes the big number one!
[Clap, clap, clap, clap]
Maijgren Village is second to none!
[Clap, clap, clap, clap]
If you like sailing, don't hesitate, don't hesitate
Come to the village that is great, come to the village that is great

Na-na-na-na-na-na-na-na-na-na-na
[Clap, clap, clap, clap]
Na-na-na-na-na-na-na-na-na-na-na
[Clap, clap, clap, clap]
If you like sailing, don't hesitate, don't hesitate
Come to the village that is great, come to the village that is great

[This second verse repeated ad infinitum]
[This song is based on the jingle from the old Clydesdale Budweiser commercials. The Maijgren adaptation dates from August 1976. Alumnus John Nelson, the Driver during that summer, was coming back from a regatta at the Sodus Bay Yacht Club when a camper, Erik "Harry" Hunter, invented the majority of the adaptation. (A rough draft of Harry's was apparently begun in 1975 and had mentioned the "King of the Bilge.")]

Documents, Songs and Stories from Camp Cory History

"Johnny Appleseed"
(Sometimes, a prank would be to sing this song at night while shining a flashlight ("sun"), dumping water ("rain") and throwing or kicking dirt ("apple seed") all in a person's face.)
O! The lord is good to me
And so I thank the lord
For giving me the things I need,
The sun and the rain and the apple seed,
The lord is good to me!

"Noontime"
Noontime is here
The board is spread
Thanks be to God
Who gives us bread
Thanks be to God!

"Sippin' Cider"
("Repeat after me" for each line, then repeat each four-line stanza all together, like "The Bear Song.")
The prettiest girl
I ever saw
Was sippin' ci-
Der through a straw

The prettiest girl I ever saw
Was sippin' cider through a straw

I asked her if
I didn't see how
She sipped that ci-
Der through a straw *(repeat)*

Then cheek to cheek
And jaw to jaw
We sipped that ci-
Der through a straw *(repeat)*

And now and then
That straw would slip
And I'd sip some ci-
Der from her lip *(repeat)*

And now I've got
A mother-in-law
From sippin' ci-
Der through a straw *(repeat)*

The moral of
This little tale
Is to sip your soda
Through a pail

The moral of this little tale
Is to sip your soda through a pail!

[There are seemingly innumerable versions of this song. Other versions end by relaying the number of children the narrator has fathered as a result of the "cider incident." Still more versions encourage the listener to drink Coke instead; for example, "Now forty-nine kids, / all call me Pa / From sippin' ci / der through a straw… / The moral of / this sad, sad, joke / Is don't sip ci / der, sip a Coke!"]

"Staff Cheer"
(Traditionally sung at Saturday breakfast before the end of a period or session. It was phased out in the early 2000s, for obvious reasons.)
London, Paris, Lisbon, Rome.
Today's the day the campers go home!
Yay, staff!

"What Do You Do With a Drunken Sailor?"
What do you do with a drunken sailor?
What do you do with a drunken sailor?
What do you do with a drunken sailor,
Earl-aye in the morning?

[CHORUS:]
Ooo ray up she rises!
Ooo ray up she rises!
Ooo ray up she rises,
Earl-aye in the morning

[VERSES:]
Shave his belly with a rusty razor (3x), Earl-aye in the morning!
Put him in the long boat till he's sober (3x), Earl-aye in the morning!
Put him in the scuppers with a hosepipe on him (3x), Earl-aye in the morning!
Put him in bed with the captain's daughter (3x), Earl-aye in the morning!
Put him in the bilge and make him drink it (3x), Earl-aye in the morning!
[The "captain's daughter" refers to the cat o' nine tails, a whip often used for corporal punishment at sea.]

STORIES

The H Man

From alumnus Jim Weller: "The legend of the 'H' man was not just a camp story; it was drama. The setting was important to the success of the tale, which was told at night, around a campfire and at the end of the event when young ears were eager for a scary ghost story. As a prelude to the story and in the midst of the campfire, some camper would nosily excuse himself for a hasty trip to the Brown house…"

Long before Camp Cory existed, the land here, where you all now sit, was a small farm. A man and his wife had come here with a horse and wagon. They were far from the nearest town, and even far from their nearest neighbor, but they had come here because the land was cheap and because they thought they had a chance at making a life for themselves.

They lived in the wagon itself during their first year here. During that time, the husband chopped down many trees, creating the field you see behind you. Finally, with enough lumber, he was able to build a farmhouse. They built the log cabin over by where the Brown house is now. It was small, with only two little windows, but it had a stone fireplace and a good, strong, heavy door. The door was strong enough to keep out the Indians and the bears that were still in the woods back then. It was also a good fireplace. It would keep the cabin warm in the winter and it was big enough to cook all their food.

The next year, the farmer continued to cut down trees and planted some crops over there in the field. The harvest wasn't very good because the soil

was poor and rocky, but there was enough to feed them over the winter. During the winter, the farmer's wife had the first of many children who would be born on their farm.

As the children became able, they helped the farmer and his wife on the farm and in the house. The husband sometimes went to town to sell his goods on the marketplace, and the wife always stayed home. The children were her only friends. But as the children grew older, they moved out, one by one. Every time another one of her children moved out, the wife became more sad and depressed. As the last of her children moved away, the wife realized that she now had no one out here in the wilderness.

The farmer and his wife would be alone for months at a time. All day, the farmer would work his small field and the wife would sit at home, alone. And when the farmer took his goods to the market, the wife would be left alone for days at a time. She was never allowed to go to town—she had to take care of the house. The wife grew more depressed and unhappy.

She started to go crazy. She would pretend things were the way they used to be. When the farmer came back to the cabin from working all day in the field, he would find the table set as if the children were all still there. But, of course, they were all gone. And there was no dinner. The wife would pretend she had a made a big meal to feed them, but the pot would be empty.

The wife did other strange things. She would make up the children's beds and pretend to tuck them in at night and tell them stories. Sometimes, when it was very stormy, with thunder and lightning, she would run out of the cabin calling for the children to come in out of the rain.

The farmer became concerned. He was worried about what the wife might do when he was in the field all day or when he went overnight to town. So on one trip to town, he bought a giant lock and some bars. He brought them home and was now able to lock the door to the house from the outside so that the wife could not get out. In order to prevent her from getting out the windows, he covered them with metal bars, too.

One time, as the farmer was about to leave to go to town, his wife became especially upset. She said she was afraid to be left alone. The farmer told her that he had to go to town or else he would not be able to sell their goods. The wife refused to calm down, and she screamed at him out the iron-barred window as he left for town, "Come back! Come back!"

The farmer was very worried about his wife and decided not to stay in town overnight like he usually did. Instead, he took his horse and carriage

and rode through the dark countryside. As he got closer to home, he saw a strange flickering in the distance, over the treetops. As he got closer, he could see that his house was on fire! He raced his horse to the house and heard his wife screaming inside.

The farmer tried to unlock the door, but the lock was stuck. He tried to bash the door in, but it was too strong. He ran to a window, and his wife was on the other side. She reached through the red-hot iron bars and pulled the farmer against them. The bars burned into his chest in the shape of a big "H." He pulled away from the house and ran screaming into the lake to put out the fire on his burning chest. Some people from the town came to investigate once they heard of the fire, but all they saw was a burnt-out shell of a house and the farmer's scorched shirt down by the beach.

There were rumors in the town that the farmer was still around, although no one knew for sure. Some people who came out this way swore that on some nights, they would see a crazy man with an "H" on his chest, running, burning and screaming, into the lake. There were others who claimed that sometimes he would grab people and take them into the lake with him.

<div align="center">***</div>

Notes:

At this point, a screaming counselor would sometimes run out from behind the Brown house (the senior bathroom) with a lit flare. He would run down through Senior Village, grabbing the camper who had gone to the bathroom at the beginning of the tale. The camper would scream "Help! Don't take me!" and the like. The campfire would end, and campers would realize that the young boy who had gone to the Brown house was now missing. His bunk might be empty all night and some burnt clothes found at the water's edge the next morning. There would even be talk of launching a search along the shore. The camper, perhaps, would be kept in the Waterfront director's "suite" in the Senior Boathouse (known circa 2010 as the "Lakeside Condo").

In other versions of the story, the farmer is overprotective and still has children living in the house. He burns the H in his chest trying to get into the house to save his wife and children. The storyteller will then relate to the campers how the H Man still roams these woods, looking for people to make

his new children. Counselors will agree that they saw him running down the road or that he jumped out of a tree at some of them while they were on their way back from the parking lot on a night off.

The H Man story is a fairly common one at summer camps, including some Finger Lakes camps such as Camp Gorton on Waneta Lake and Camp Stella Maris on Conesus Lake.

Little Willy

Little Willy was a farmer's dog. He was a very trusted dog and often accompanied the farmer when he went out hunting. He lived in the Penn Yan area before it was well settled, so there was plenty of countryside for Little Willy to roam around in during his free time.

One day, when he was out roaming at the edge of the woods, he came across a beaver. At first the two animals were wary of each other, but they became fast friends. They wandered the woods and creek beds together, and they would wrestle and chase each other through the fields. They were great friends.

There came a time, though, while Little Willy was off hunting with his master, that the beaver was bitten by another beaver and contracted rabies. When Little Willy returned, he played with the beaver just like always, but the beaver accidentally bit Little Willy, infecting him. After a few days of progressing illness, Little Willy died.

Because his family loved him so much, they made a grave just for him in the cemetery. On top of the grave they carved a statue of Little Willy, with his paw covering the key to the house, to symbolize the trust they had placed in him and how important he had been to the household.

Originally, the statue of Little Willy faced straight forward. After a little while, though, the beaver died and wanted to be near his old friend again. Once the beaver died, a stain appeared on a grave right across from Little Willy's grave. The stain was in the shape of a beaver. The beaver had just wanted to be with his old friend again, but Little Willy was not so forgiving. Ever since that day, the statue of Little Willy has faced to the side so that he will not have to stare at the beaver, his killer, for eternity.

Rominy Gruen

It was forty years ago when Rominy Gruen came to Camp Cory. He had never been to camp before, and like any first-time camper, he was nervous

about staying overnight away from home. He hadn't been at camp for too long when, exactly forty years ago from tonight, he heard something outside his cabin in the dark. His counselor had left the cabin for the night, as counselors did back then. Rominy lay in his bed, in the dark, when he heard a voice calling from out in the night: "Rominy…Rominy Gruen! Ro-miny… Rominy Gru-en!"

Rominy tried to ignore it; he was terrified. But after a few minutes he couldn't ignore it any longer. He had to see who was calling his name. He got up out of his bed, put on his sandals and walked out the front door to the cabin, into the night.

He was never seen again.

Twenty years later—that's twenty years ago, to the day, from tonight—another camper was staying in the same cabin. He was like Rominy; this was his first time at an overnight camp. That night, at the campfire, a counselor told all the campers the story of Rominy Gruen—how something had called his name and how he had never been seen again. The new camper was lying in bed awake that night, listening to the sound of the wind through the trees, and maybe in the distance could even hear the waves on the beach. Then, clearer than anything, he heard, "Rominy…Rominy Gruen…Ro-miny… Rominy Gru-en."

The new camper tried to shut it out, but he couldn't. He kept hearing the voice out in the darkness, calling: "Rominy…Rominy Gruen…Ro-miny… Rominy Gru-en."

Finally, the boy decided he had to go see who was calling out in the night. The camper climbed down from his top bunk and went outside to investigate. He was never seen again.

Now, tonight is forty years, to the day, from when Rominy disappeared. It is twenty years, to the day, from when the other camper disappeared. If something happens, it's going to be tonight…

<p style="text-align:center">***</p>

NOTES:
Often, after telling this story, counselors would call out in the night after they had left their cabins for the evening. Younger campers were known to go to

bed with baseball bats. In some versions of the story, it is Rominy himself who calls out each summer after that first fateful night. In other versions, Rominy had been found hanging from a tree the next morning—a rope would be seen hanging from a tree the morning after the story was told.

For a similar story, see "The Wendigo" in Alvin Schwartz's *Scary Stories to Tell in the Dark* (HarperTrophy, 1981). Tales of ghostly voices calling out to terrified sleepers in the night are centuries old. "The Golden Arm" is probably the most famous example. In that story, a golden-armed corpse is buried, grave robbers steal the arm and the corpse comes back to seek vengeance (or, at least, its arm). Mark Twain told this story on the lecture circuit and included it in *How to Tell a Story and Other Essays* (1897). Other versions have a corpse being buried with silver dollars on his or her eyelids. See "Clinkity-Clink" in Schwartz, *Scary Stories*. The story goes back to old Europe, where it was a folktale recorded by the brothers Grimm.

The Story of Gillette

There was a well-to-do woman in Penn Yan named Gillette. She had much local influence and was well known throughout the region as a philanthropic, albeit lonely, woman. As she was reaching her twilight years, she met a man named Bishop and fell in love. Her family tried to convince her that she should not take up with Bishop because he was such a young man. They tried to convince Gillette that he was only in it for the money and that he didn't really love her. Gillette wouldn't hear any of it.

Gillette and Bishop married, but after a year or so, Gillette became ill. It soon became apparent that there would be no recovery, and she called Bishop to her bedside. She told him that she had written him into her will and that he would be receiving her vast fortune upon her passing. She made him promise, however, to spend the money wisely. She made him promise that he would continue to represent the Gillette name in a good light, that he would be philanthropic with the money and not waste it. Most of all, she made him promise to never remarry or find another woman. Gillette thought this a reasonable request because, after all, she believed that she and Bishop were truly in love.

Gillette died, and after about six months Bishop began squandering the money, throwing lavish parties and taking up with many girlfriends. Shortly thereafter, the troubles began at the Gillette mansion. Books would fly off the walls without explanation. On several occasions, silverware would fly

from the table, clattering to the floor. Banging noises echoed throughout the house at night, and doors and windows rattled in place.

A local reporter caught wind of the rumors that were spreading through town, and he decided to write a story about it. With Bishop's permission, the reporter came to the Gillette mansion and even spent the night. While he was there, he witnessed several instances of what would later be called "poltergeist activity." He saw objects inexplicably thrown around as if from a ghostly source, and a mysterious banging kept him awake throughout the night. It all went into the newspaper, and this became one of the first modern written records of a haunting.

The regional newspapers became interested and, after that, the national newspapers. It became something of a rite of passage for a newspaperman to spend the night in Gillette Mansion and to write a chilling story about the experience for the Saturday evening edition.

Bishop was terrified throughout this entire ordeal, and about six months later, the silhouette first appeared on Gillette's gravestone. The silhouette at first appeared to be a stain or the work of vandals, but most people who saw it noted that it looked extraordinarily like the outline of Gillette's face, lying supine.

Bishop replaced the stone with a second, unblemished stone. The next day, however, everyone in town was talking about how the new stone now had the same exact stain on it in the same exact place. Ripley's Believe It or Not heard of the story and offered to buy the grave from Bishop. Bishop, who was fast running through the Gillette fortune, was only too glad to accept. The grave went to the Ripley's museum in Niagara Falls, and a third stone was placed in the Penn Yan cemetery, under twenty-four-hour guard. Ripley's analyzed its stone to see exactly what the "stain" was and noted that it was not a superficial mark; instead, it ran more than halfway through the huge piece of rock, as if it were a discoloration that had always been there.

For days nothing happened, and no stain appeared on the third stone in Penn Yan. One night, though, the guard was patrolling around the grave with his lantern when he heard a rustling in the nearby bushes. Thinking he had heard the vandals who were responsible for this whole mess, he headed over to the bushes. There was nothing there. He was gone from the grave site for no more than a minute, but by the time he returned, the stain was once again upon the rock!

Documents, Songs and Stories from Camp Cory History

Meanwhile, at the Ripley's museum, the stain from the second stone had disappeared overnight. Ripley's disposed of its blank, now-worthless stone, and its location is currently unknown.

The third stone still remains at the Penn Yan cemetery, and visitors can still go there to see Gillette's outline. It is common knowledge that visitors should respect Gillette's stone; Cory history is replete with tales of bad luck befalling those who do not treat the stone with dignity. On a 1995 Wells Village trip, two boys kicked Gillette's grave. One of them twisted his ankle getting back into his canoe at Indian Pines Park. The other, upon stepping out of the canoe back at camp, promptly broke his ankle. Many campers who have attempted to photograph the gravestone have capsized their canoes or kayaks on the return trip to camp, and a group of staff members who photographed themselves at the stone had the picture developed only to see a dark, stormy sky that had not been present when they had taken the picture.

On the other hand, a young girl who visited on one of the camp trips collected thistle flowers on the walk from the park to the grave. She then laid the flowers all around the grave. Upon returning to camp, she purchased a bag of M&Ms at the store to discover that she had won second prize in the infamous "find the gray M&M" contest!

Gillette's grave remains, stalwart, at the cemetery in Penn Yan, waiting for its next visitor.

NOTES:
See also Herbert A. Wisbey Jr., "The Lady in Granite," *The Crooked Lake Review* (October 1994). Wisbey notes that a nearby grave with a beaver-shaped mark on it has no local story to go along with it; see the story above, rebutting his claim.

The grave is located in Lakeview Cemetery, on West Lake Road adjacent to the Jerusalem town boundary.

In some versions of the story, Gillette's wealth comes from the fact that she owned the Gillette Company of razor blade and shaving cream fame. In other versions, the security guard worked at Ripley's in Niagara Falls.

The Turtle Story

A ways down the road from camp there is a small pond. Among some of the garbage and muck in the pond is a small family of turtles: a mother, a father and "Junior." One day, Junior was swimming around in the pond when his eye spotted an old newspaper with an advertisement on it. The advertisement was a picture of a family sitting on a sunny hill, eating out of a basket.

Junior rushed home with the advertisement in one hand. He hurried into the house and went over to his father: "Dad! Dad! Look what I found!"

"What is it, Junior?" the father asked.

Junior showed him the advertisement. "What are they doing, Dad?"

The father looked at the picture and then explained, "They're on a picnic, Junior."

"A picnic? What's a picnic?"

"Well," the father began to explain, "a picnic is when you get a bunch of food together, put it in a basket, bring along a blanket and go eat all of the food outside, in the nice weather. Then you all play leapfrog and have watermelon seed–spitting contests."

"Wow!" Junior exclaimed. "That sounds amazing! Can we please go on a picnic, Dad? Please? Please?"

The father thought for just a moment or two and then decided, "Yes! We will go on a picnic. Tomorrow! Dear," he shouted into the kitchen, "we're going on a picnic tomorrow with Junior! His very first picnic, in fact!"

Junior's mother came into the room. "Why, that's wonderful! You two get the basket, blanket and sandwiches together. I'll get the watermelon, the lemonade and the veggies. And, to celebrate Junior's very first picnic, I'll bake a batch of my extra-special secret-recipe chocolate cookies!"

Junior was so excited he could barely sleep that night. The next day, the Turtle family set out for their picnic. They strapped the basket to the father's back, and they strapped the blanket to the mother's back. They walked and walked all day, into the night, and all the next day. They walked some more. They rested for a half-day or so, and then walked for three more days. Finally, they found a spot that was just perfect for a picnic.

"Here!" The father declared, and he set down the picnic basket. The turtle family was unpacking all of their things when the mother suddenly made a horrible realization: they had forgotten the lemonade!

The family was distraught, Junior most of all. "Well," the mother said, "I guess one of us will have to go back for the lemonade." Junior was the least

tired of all of them—since he hadn't carried anything to the picnic—so it was decided that he would go.

"Now wait a minute," said Junior. "While I'm gone, you're not going to eat anything without me, are you?" The parents swore that they wouldn't. "Not even the chocolate chip cookies?" The parents swore, not even the chocolate chip cookies. "You won't have even one tiny chocolate chip cookie without me?" No, they swore, they wouldn't have even one tiny chocolate chip cookie without him. Junior set off for the lemonade.

A day passed, then two, then three. It was after about the first week when the parents began to get worried. "Where is Junior?" they asked each other. Moreover, they were famished. "Well," the father reasoned, "it couldn't hurt to just eat a little bit of the veggies to tide us over." They hemmed and hawed about it for a while; they were starving, but they also didn't want to break their promise to Junior. Finally, they relented and ate some of the veggies.

Another week passed. The mother and the father were forced to eat the rest of the veggies and most of the watermelon. Another week passed, and they finished off the watermelon and the sandwiches. By this time, they were growing more and more concerned that Junior might never come back.

Finally, there was nothing left but the cookies. The father wanted to eat them, but the mother said, "No, we promised Junior especially not to eat the cookies."

"But we might starve!" the father groaned.

"Well…" the mother relented, "we'll just wait one more day for Junior to come back."

The day came and went, and there was still no sign of Junior. The father took a chocolate chip cookie out of the bag, held it in his hand, looked at it and moved it toward his mouth, just about to take a bite…

Just then, Junior jumped out from behind a nearby rock and yelled, "Aha! I knew it! Don't you dare take a bite of that cookie or else I'm not going back for the lemonade!"

<p style="text-align:center">***</p>

See Katharine M. Briggs & Ruth L. Tongue, eds., "The Tortoise's Picnic" in *Folktales of England* (Chicago: University of Chicago Press, 1968).

Roger Bubel told his version to Cory Campers, in possibly its first appearance at Camp Cory, at the Thunderbird in 1975. This tale, like so many others, can and should be expanded to include zany dialogue and physical animation of the storyteller. For sending me a lengthy, detailed version of the story, I am indebted to Dave Knittel (counselor, 1975; Iroquois Village head, 1976; program director, 1977–78, 1981–82; leadership director, 1985), who told it at the eightieth reunion campfire in 2001.

THE CAMP CORY ANNALS

A brief timeline, continued:

1929

Camp Cory obtained modern-day Junior Village from the Penn Yan Country Club (now the Lakeside Country Club). The now twenty-seven-acre camp split into senior and junior sections, with the junior campers sleeping in cabins instead of tents. Senior Village tents began to be gradually replaced with cabins.

1935

The camp, satisfied with the use that its rented sailboats had seen during the previous summer, purchased four new sixteen-foot-long K-boats.

1937–38 (winter)

Eleven new permanent cabins were erected in Senior Village. Heavy-duty construction equipment filled in the waterfront area near Senior Village so that three cabins could be built near the shore for the oldest campers. These tents would later become Waterfront Village and are presently known as Maijgren Village.

1939

"Waterfront Village" and "Walmsley Village" become official village names. Walmsley Village was named after J. Milnor Walmsley and his wife, who had both been involved in boys' work in Rochester for some time.

An old picture of Junior Village, facing north.

late 1930s–early 1940s

The camp held sailing eliminations every two weeks for the "Tom Sharpe Cup," named after the Rochester Yacht Club commodore who had won the Canada Cup. By 1941, the camp owned eleven sailboats, and campers could attain the rank of cabin boy, midshipman or seaman for their sailing skills. The rank of skipper would be added the following summer.

mid-1940s

Many staff members and would-be staff members fought in World War II. Camp Cory was forced to accept younger counselors and abandoned the village designations for a summer or two. The war veteran counselors told war stories around the campfires upon their return.

1947

The first references to "Wells Village" appeared. Schuyler Wells was a former camper, staff member and chairman of the camp Committee of Management.

1950

Camp Cory purchased a sizeable portion of land in Guyanoga, a hamlet to the north of Branchport. Campers had been taking trips to this piece of land

as early as 1925. This relatively wild and untamed land is currently used for Outdoor Education.

1952
Junior Village was officially referred to as "Iroquois Village."

1953
Camp Cory's counselor-in-training program began. CITs originally attended camp for two consecutive nine-week summers in order to aid the camp and to receive leadership training. During their first year, the CITs would rotate two weeks in the dish room, two weeks in the CIT cabins. Second-year CITs were assigned the duty of dining hall supervision.

late 1960s–early 1970s
In 1968, the former Waterfront Village was called "Sailing Village," and it was at this time a separate program for which a camper had to specifically sign up. The following summer, the village was renamed "Windjammer Village." Finally, in or around 1971, it was renamed "Maijgren Village" after Mike Maijgren, the former camper, staff member and board president.

1976
Female campers and staff are first accepted at Camp Cory.

1990s
Most of the cabins in Senior Village were renovated.

1998
Camp Cory switched from two-week periods to one-week sessions.

2003
Iroquois Village was renamed Craig Village. A climbing tower was built in Junior Village.

2005
The dining hall was renovated extensively. The CIT cabins were torn down and the Mangurian Leadership Lodge erected in their place.

2008
A high ropes course was built in Junior Village, high above where the arts and crafts lodge had once stood.

2010
The camp office building, one of the oldest buildings in camp, was renovated to better reflect its original condition. Historical items, photos, lists of staff positions and portraits of former directors were placed on its walls.

Between 1922 and 1964, Camp Cory published yearbooks called "culminaries." These booklets are, by far, the best publicly available sources of information about the way the camp operated each summer. Other sources (such as letters, reminiscences or the several iterations of camp newspapers) are obviously more detailed, more candid and may give a reader more of an idea of what it was actually like to be a camper or counselor. I shall try to include these sources where I can. However, the culminaries are comprehensive, consistent and coherent. This "story of years" is largely based on information gleaned from those booklets.

Camp Iola was over; Camp Cory had begun. Camping had occurred at the Keuka Lake site in **1920**, although it is unclear whether this camp was called "Cory," "Iola," "Rochester YMCA Camp" or had no official name. In that year, camp was just the lodge (dining hall), a lakefront cottage and ten tents. The campsite on Keuka Lake was officially dedicated in 1921 as YMCA Camp Lawrence Cory. It was a mere thirteen acres at this point; all of what we would now consider Junior Village still belonged to the Penn Yan Country Club. No **1921** culminary is extant, if one ever existed. All that remains from that year is a year-end banquet itinerary.

Cory boys, circa 1921. I have found some of the handwritten dates on photos to be inaccurate.

The **1922** culminary describes a young camp hacked out of the wilderness. Much of the staff had carried over from Camp Iola. Campers arrived on "a rainy Thursday morning[,] June 29th." Over the course of the summer, campers took trips to "Indian Village," the Yates County Picnic, Camp Arey, Steuben County Camp and "Otentiana." Sixty different types of bird were spotted on these and other field trips. One of the more popular activities at camp, it would seem, was the Radio Department; campers and staff built a forty-five-foot mast with wires to broadcast. Campers also had the opportunity to put on a minstrel show at the now-defunct Elmwood Theatre in Penn Yan. The culminary mentions one camper who traveled on his own to Penn Yan and stayed out until after "Taps," one camper who "sampled" for a few days and one camper named Mike Maijgren (who would become one of the more well known and influential men in camp's history). These campers, as well as all the others, participated in a "Personal Attainment System." Three "degrees" were awarded in 1922. Although we know little of the requirements this summer, it was clear that one of the criteria for obtaining the second degree was to pass a first aid test of some sort. The camp's truck driver slept in a tent (possibly with campers) and attended college the following fall—this is the first of many bits of evidence showing a nebulous and blurred line between what we would now call "staff" and

RULES AND REGULATIONS FOR HIKING PARTIES

FROM ROCHESTER "Y" CAMP.

CAUTION

Be careful of the drinking water. Follow instructions.

Do not allow drinking while on the hike.

Do not rush. Rest during the heat of the day.

Respect farmers' property. Do not cross grain fields.

Avoid trouble.

Be careful of fires. Be sure they are put out before leaving.

Be careful of blisters, cuts and bruises. Wash feet twice daily.

Change socks at least once a day.

Watch your boys carefully for fatigue. Do not permit anyone
 to overdo.

Stick together. This is essential.

Auto rides are not permitted. You are hiking not automobiling.

We have found it best not to allow swimming on hikes.
 "SAFETY FIRST".

Hiking rules, circa 1922.

The old Council Ring, likely located near present-day cabin S-8.

The Camp Cory Annals

"camper." "Social activities" were planned by the "social committee," which may have been equivalent to the modern-day program directors. July 4, 1922, saw the dedication of another important building at camp—the Isabelle Cook Manual Training Building, now known as the camp store.

The **1923** culminary was dedicated to Clark L. Oviatt, a young counselor who had recently died off camp in a tragic campfire accident. He had been named in the above-mentioned 1921 itinerary, and as of 2011, a plaque still hangs in his honor at the camp store. The camp now had a new boathouse, a new fence, new tennis courts and baseball backstops, bleachers and a pump. That summer, 234 boys and "leaders" attended, with an average of 118 per week. Four weeks at camp was considered a short stay. The Radio Department achieved at least some success this summer, hearing transmissions from as far away as Miami and Oakland. The culminary also mentions a "5ᵗʰ emblem" in the attainment system, although requirements are still elusive. Campers enjoyed drilling a well, putting on a water carnival, "stunt nights," attending meetings of the Corian Club dramatic organization and putting on *Cory Capers*, a play that premiered on July 23 in Penn Yan, accompanied by a musical revue. Campers once again sojourned to Otentiana, and also to Watkins Glen. The camp library was stocked with one hundred books. Chapel speakers that summer included both the Keuka College president and Reverend Moore of Ithaca, New York. "Doc Green" brought his wife

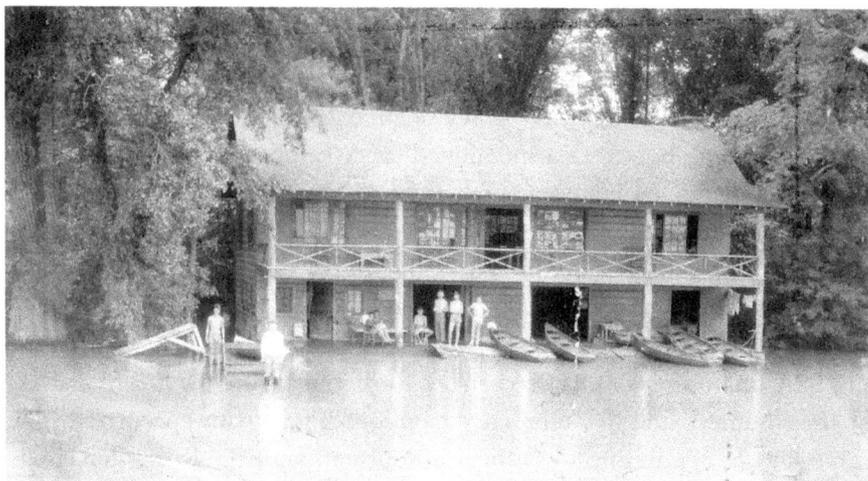

The old Senior Boathouse.

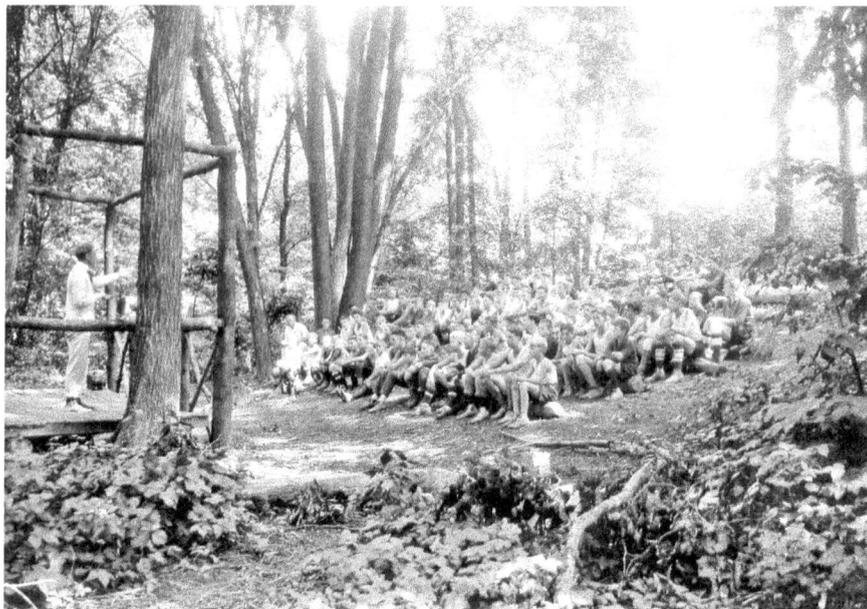

The chapel, 1922.

to camp—this is noteworthy for being mentioned in the culminary and also because in later years women (even wives) were strictly forbidden from stepping on camp grounds. Camp Director Frank Gugelman was sick one morning and had the pleasure of being carried to the mess hall by a group of leaders. Finally, it is interesting to note that the culminary writers were much less sensitive in those days than any Cory staff are today: the culminary mentions Edward Hoffman, nicknamed "fat"—"the guy who shakes the tent every night. Also the tent's heavyweight eater." Indeed, each "tent" had a blurb written about it that mentioned every camper and leader from the summer. Finally, the culminary noted its wish list for potential donors: a health lodge ($1,800), silverware ($600), a boat launch ($1,000), roadway ($300), a graded baseball diamond ($500), larger toilet facilities ($1,000), a concrete swimming dock ($1,000) and two hundred more books ($300).

In **1924**, an outbreak of sickness struck the camp during the first five weeks of the summer. Still, the culminary mentions fun activities occurring. The camp library, apparently, was officially a substation of the Rochester Public Library, 125 books strong. A group of campers took a sand barge trip to

Bluff Point one day, returning by moonlight. Finally, the culminary faithfully describes the old Camp Cory Emblem. The design was a blue felt inverted triangle (known as the "Gulick" triangle) surrounded by a white border, with a white C in the middle. A gold star on each corner would indicate which "degree" a camper had attained in the achievement system. Photos from this decade show some familiar buildings but also some that are unfamiliar. The dining hall is located where it is currently and looks very similar from the outside. The Isabelle Cook building, now the camp store and office, looks familiar, although in the early 1920s it was only half the size it is now (modern visitors to camp can still see where the old roof ended). However, there are some strange buildings on the shore. A tent likely housed staff members, and a large building below the dining hall was then the camp store and office. A small cabin between the beach tent and the office was almost certainly the camp director's cottage; its concrete foundations can still be seen on the shore today, between cabin M-5 and the yacht club.

The Cory emblem with one degree star at the bottom corner.

The dining hall, sometimes called the mess hall or the Cory lodge.

Above: Three now-unfamiliar lakeside buildings, early 1920s. The director's cottage is at center.

Opposite, top: The camp store and office, the northernmost of the three lakeside buildings.

Opposite, bottom: The director's cottage, 1920s.

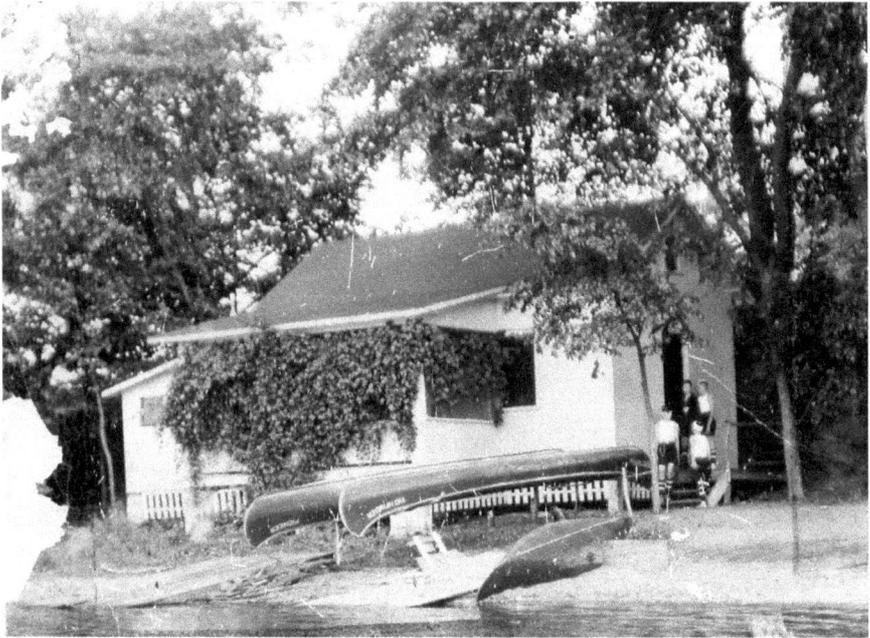

This page: Winter 1924–25: "The big snow wrecks the boathouse."

The Camp Cory Annals

The **1925** culminary describes the camper/staff juxtaposition in some more detail. Campers who were fourth-degree candidates in the achievement system would often help with games and "stunts." At the same time, junior leaders were still thought of as pseudo-campers.[1] The "master of the lodge" ran things in the dining hall (then sometimes known as the Cory Lodge). A third cottage was erected, possibly on the waterfront, and probably to house staff. The camp was obviously more religious in these days—daily devotionals followed breakfast, each tent held "vespers" at night and, on Sundays, non-Protestants had the option of going to town to attend other churches. Finally, it was in this year that camp said goodbye to Frank Gugelman, who had been director since the Iola days. After 1925, he was chosen to visit other YMCA camps to ensure that their standards were up to snuff. His replacement would be Dougal E. Young, the assistant director. Some issues of the camp newspaper, *Cory Clips*, survive. It would seem that

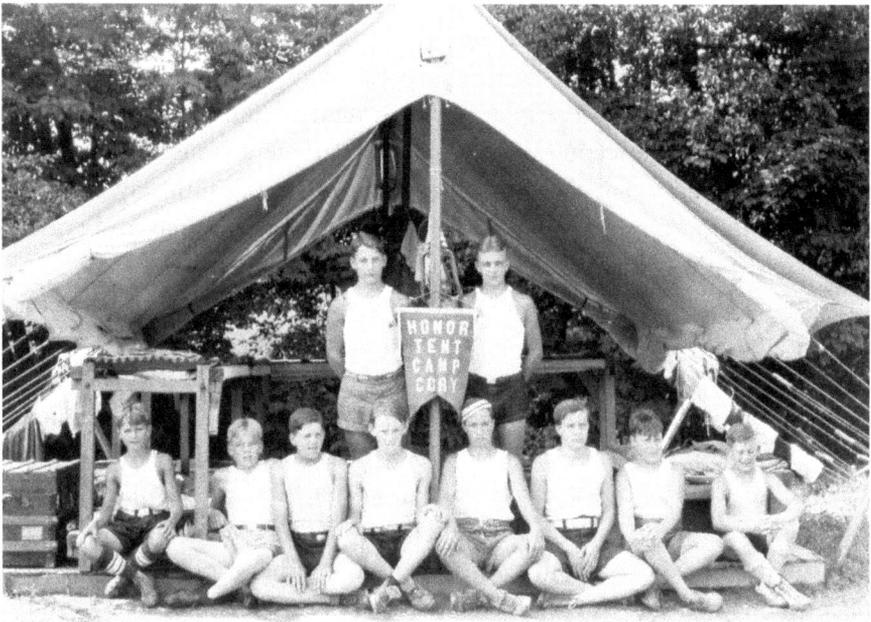

A tent in 1925.

1. As far as I can tell, junior leaders were campers who were chosen to assist counselors in tents. Sometimes they are listed as being a camper in one tent at the beginning of the summer and a junior leader in a separate tent at the end of the summer.

campers had to purchase an issue of *Cory Clips* and that it was cheaper to get a subscription than to buy the newspaper at the "candy store." Forty cents bought the season issues. There was a gossip column, which advertised: "Ye editor, may be approached at any time after midnight at the flag pole of the campus, and the price of your name in the issue may be talked over with him at his office. Liberal sums will be paid for news which will be fit to print as this will be the policy of this page—only news which is fit to print, for we must be fair with the leaders." One gossip story related the tale of a young leader who often canoed across the lake, perhaps on his way to a nighttime assignation.

In **1926**, the Isabelle Cook building was doubled in size. In addition, parents and friends of boys from LeRoy, New York, presented a new "hospital building." It was dedicated on July 11 and remains the LeRoy Health Lodge. This summer the camp was host to 270 campers and leaders, with an average of 136 per week. Once again, a musical comedy, this one titled *Our Gang*, was staged in the village of Penn Yan. The culminary tells us that every boy received a physical examination during his first few days at camp. It also explains the content of the first aid course (a requirement for the second degree of the attainment system): there were four talks of one hour each, with a test given on the fifth day. Another aspect of the attainment system is revealed in the culminary: obtaining the first degree was a prerequisite for a boy to receive the Cory "C," mentioned above. Campers and staff took water samples of the lake and sent them to Rochester every few days; whether this was for fun or for some ominous purpose is unknown. Soldiers and Sailors Hospital, the mainstay of the Cory walking wounded, existed in those days and was sometimes used. The camp was shockingly ignorant of potential liability, or at least shockingly blunt about it in a publication that was sent to parents: the culminary mentions that the slide and dock kept breaking and falling over, and mention is made of one camper who had a habit of "falling off the dock when no one was around." One final word must be said about 1926: it was the year during which *The Rajah's Rubies* premiered. Several copies of the script for this play survive. It was written by Philip Will Jr., the dramatics director. The donor of one of the scripts now in the archives attached a letter in which he described how the play was serialized (into either three, four or eight parts) throughout the summer. He was not to

The cover for *The Rajah's Rubies*, an early, serialized staff show performed on Saturdays. The donor of this copy of the script took a steam train to Penn Yan in 1926 just to catch the last act.

be at camp for the final part, but he wanted to know the ending so badly that he took the train down to Penn Yan just to see it! The script is long and detailed, like a real play—vastly different from the rough outlines and improvisation that rule the stage nowadays.

The Last Page of The Rajah's Rubies

-37-
[…] His Majesty, the Rajah of India, sends word to his faithful servant, the Grand Vizer [sic]*, that he has been sent on a fruitless mission. His Majesty had been misinformed, and has since discovered that the rubies have as usual been within the royal domicile. His majesty found them in his other pants pocket. His majesty orders the Grand Vizer to return immediately to India.*
Signed,
Secretary to His Majesty
Sir Loin Steaks.

Gentlemen, my part is played. May I have your permission to leave?
Earl *Your apology is accepted. You have our full permission to leave. Issea, return Sir Ivan's knife and allow him to pass.*
Ivan *Gentlemen, I bid you good night and goodbye. (Exit Sir Ivan. Guests take leave also. Enter butler, who converses with Indo.)*
Indo *Excuse me a moment, gentlemen. (Exit Indo and enter Ruth.)*
Ruth *Hugh, how can you ever forgive me for what I did this morning?*
Earl *Ruth, how can I blame you? Now that the danger is over, I have something far more important than rubies to discuss with you.*
Ruth *Yes, Hugh.*
Issea *Dis looks like love, acts like love, and I betchu it is love.*
(As they clinch)
CURTAIN

Mr. Harvey E. Cory, father to the slain Lieutenant Lawrence Cory, gifted a new baseball diamond to the camp in **1927**. The soil on the field was

"loamy," so campers could still play after a heavy rain. Camp Iroquois, from the Elmira YMCA, challenged the Coryites on their new home field. Camp Pioneer, a Boy Scout camp on Seneca Lake, may have done so, too. New stone embankments were built between the tennis courts, and the boathouse received new footlights, curtains, makeup tables and costumes, making it an "almost professional" theater. It was perhaps these latter additions that inspired the camp to write and perform *The Purple Pest*, another serial play that was perhaps even more popular than *The Rajah's Rubies*. This summer, and possibly in other summers, campers received a physical before leaving camp in order to note the boys' growth and muscle development. As for skill development, the 1927 culminary explicitly mentions some more of the requirements for the camp attainment system. To obtain the first degree, a boy had to attend five hours of manual training, through which he would build a small object, and he had to observe five birds; there may have been other requirements as well. To obtain the second degree, a boy had to (at least) collect ten wildflowers, press them and identify them. To obtain the third degree, requirements included making a piece of furniture for the camp, as well as gathering and naming twelve different leaves. To obtain the fourth degree, a talk at chapel was required. Other requirements for certain emblems involved passing boating tests and signaling tests and leading

The boathouse stage.

The cook building, now the camp store and office. Note the small size of the building.

games such as dodgeball and "spud." Tents continued to have "vespers," a more religious version of the modern nighttime devotional, every night. Throughout the 1920s, we learn, camper "mysticals" were carried out. The culminary writers hadn't lost their disparaging touch: on page 27, while describing campers, we read, "In every tent there must be a fat boy."

A common prank in **1928** was to try to convince new campers to hunt for "red oil" or for "tent stretchers." The culminary also notes that points toward the "C" attainment program were scored in the main athletics competitions. The serial play this summer was *Ray of Death*, though no mention is made of whether its popularity surpassed the plays from the preceding two summers. Apparently, campers had the option of either staying in their tent or going to the social programs in the evenings. Mention is made of a hierarchy of "staff," if we can even attribute the same concept of "staff" to the camp in the 1920s. According to this hierarchy, junior leadership was below senior leadership, which was below faculty. Whether the "faculty" were the only true staff members, whether only the top two levels were counted as staff or whether the line was simply ambiguous is unknown. The culminary went to press August 15, before the season was even over. The goal of this was to have copies of the book ready for the banquet at the end of the summer.

The official history of the Lakeside Country Club states that it sold its property to Camp Cory during the Great Depression. But seeing as how the

The Camp Cory Annals

Depression started in October **1929**, and seeing as how Camp Cory's Junior Village was already obtained by the summer of 1929, I respectfully contend that the country club's history is in error. Yes, by 1929 another portion of the camp had been purchased, extending it northward and including all of modern Junior Village, all the way up to the northernmost ravine of modern camp. The junior camp had cabins, not tents (see a related newspaper article in Part I), and they all had Indian names. The younger boys awoke to reveille at 6:45 a.m., had a rest hour after lunch and went to bed to an 8:30 p.m. "Taps" bugle. The culminary devotes much space, and rightfully so, to the new addition of land and program at Camp Cory. We also learn what it took to be able to boat without a leader present: campers had to pass a fifty-yard swim test to obtain this privilege.

In **1930**, the lodge (read dining hall), boathouse and cottages were all painted brown, replacing the gray that had seen them through Camp Cory's first decade. The nature lodge was either built this summer or had been recently built; before this edifice, nature class had taken place in the Cook Manual Training Building. Two Sundays after the Fourth of July, a new outdoor chapel was dedicated. This year also brought a new photography and printing program to camp. By now, independent camper trips to Penn Yan were limited, implying that throughout the 1920s many campers had been free to travel alone! The tents on the senior side of camp were split into four "villages:" 1–4 were Mercury, 5–8 were Erewon, 9–12 were Bedlam and 13–16 were Utopia. There is little mention of these villages in the culminary or what purpose, if any, the designation served. It would also appear that these village designations only lasted a summer or two. The attainment system added (or reintroduced) a fifth degree, possibly to find something to do with the slew of boys who had already attained all four degrees. Just as degree earners helped with activities, so, too, did the junior campers have help: they elected "junior councilmen" to assist with things. The waterfront had a diving tower, located about fifty yards from the shore. It was from this tower that Mike Maijgren, Fritz Yust[2] and Lefty Meyers shot off the July 4 fireworks. The camp, by now, had an archery program. Campers received archery ribbons and could be members of the Archery Club. For the athletics games, similar to previous years, teams were semipermanent throughout the

2. A noteworthy fellow in those early days, W. Frederick Yust was Librarian in 1926–27 and Social Director in 1928, 1930 and possibly 1929.

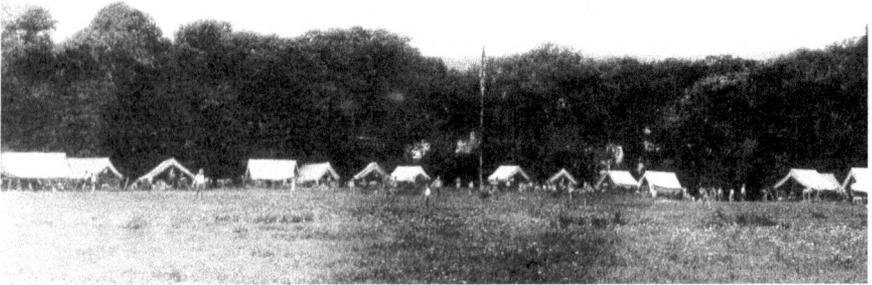

Senior Village tents.

summer. In 1930, the teams were the Bucknells and the Cornells. Campers who got sick could always visit the nurse, who made fudge. Dramatics seems to have been running out of ideas, or at least acquiesced to popular demand, because it put on a reprise of *The Rajah's Rubies*. Thanks to a new Waterfront director, the camp first introduced the "buddy" system. Campers in the water could be no more than ten feet from their respective buddies. Charles W. Carson, the first program director mentioned in the culminaries, began keeping records of camper attainments; he was also known to golf nightly. Dougal E. Young, the man who had replaced Frank E. Gugelman in 1926 and whose last summer was 1930, had three children. Carson would replace him the following summer.

Visitors came to Camp Cory in **1931** from Camp Pelion, operated by the YMCA in Athens, Greece. Pelion and Cory were sister camps for some time, sending each other letters and gifts. Pelion named one or two of its buildings for Cory after Cory campers and staff sent donations. Cory campers took overnight trips to Branchport, around the crook of Keuka Lake, in the camp's war canoes. There were also trips across the lake, hikes to "6-mile point" and the first ever Junior Village trip to the Bluff. On the subject of boats, the culminary writer noted, "There is some talk of introducing regular sailboats within the next few years." Just as in previous years, campers pulled pranks on newcomers: rookies were told to find nonexistent "skyhooks," "red oil," the key to the pitcher's box or the key to the rowboats. Snipe hunts

were known to take place in Junior Village. The dramatics supervisor was a college professor and produced classically done plays (although one must wonder how much success he had). Parents might have a chance of seeing their boys on Visitors' Sundays. One Sunday, the Camp Cory Army stormed the mess hall. In the culminary, counselors are designated as belonging to specific program areas; "utility" counselors filled in for other counselors who were on leave. One of these utility counselors, Robert Van Voorhis, gave readings from his book, *How to Be a Successful Counselor, and Why I Was.* In another sign of the strange camper/staff boundary, several of the older campers were to enter college in the fall. At the end of the summer, a new cabin was erected for faculty in Junior Village. The culminary includes a farewell reminiscence, which I include here in full: "It's good to think that it will all come again after a few months. And it's good to sit by my fireside and chuckle to myself, and sip my gruel, and remember…bits of laughter, a kid with a four-inch fish, an occasional wise-crack, the big, wide, starry nights… hazy memories they are, but strangely beautiful."

The **1932** culminary is quite different from its predecessors. Instead of blurbs about each tent, camper and counselor, there are dozens and dozens of headshots of all campers. There is, therefore, less information about the operation of the camp during that summer, but what information there is interests us. According to the culminary, there were no compulsory activities, as hard to believe as this may be. That summer, there were also over two hundred applicants for just twenty-five counselor positions (the culminaries gradually begin using "counselor" instead of "leader" around this time). Camp Cory played twelve inter-camp baseball games, winning seven of them. The culminary makes only quick, passing reference to the Depression that was raging all the while around the country. The Handicraft Department manufactured bows and arrows and then shot them. Lastly, campers engaged in a form of advanced woodworking: totem pole building. The end result of this project was the completion of a symbol that would represent camp, in one form or another, for decades to come—an Indian thunderbird.

The **1933** culminary begs parents not to send sweets to their boys at camp. Reports, including physical descriptions, were sent to parents of boys who stayed more than four weeks. Off-camp trips were now so popular, or so rare, that there was a wait list just to participate in one. The camp received

a new boating dock and tower on the senior side of camp. We also learn, in greater detail, what a typical daily schedule was for a Junior Village camper. In the mornings, activities were open and campers could choose which they wished to attend. In the afternoons, campers had a rest hour, after which they would either take a trip or learn about Indian lore (even in these days, before it was called Iroquois Village, the junior side of camp was very Indian-themed). In the evenings, junior campers participated in four groups of competitive games, and at night there were campfires, stories, movies or the occasional party.

The year **1934** marked the fiftieth anniversary of organized camping—YMCA Camp Dudley, founded in 1885, is generally considered the oldest summer camp around. So while 1934 did not technically mark the "anniversary," it nevertheless marked the fiftieth summer of organized camping. In another message to parents, the culminary writer notes, "Homesick campers are frequently less of a problem than boy-sick parents." The message? Visit less. Camp Pioneer sent two baseball teams to Cory for a whole day, and in the spirit of inter-camp sportsmanship, Cory later did the same. Blasting took place near the diving tower and diving board in an attempt to deepen the water. The archery program, it turns out, was

The Senior Boathouse social room.

officially a subcategory of the handicraft program, not athletics, probably because much of the focus was on the campers actually making the bows and arrows. Boys took trips to Glen Arey, Guyanoga, Glenora, Watkins Glen and Wagner Glen. On one of these Guyanoga trips, the campers or their counselor caught an owl and brought it back to live at camp. Junior campers took overnight canoe trips to a campsite six to seven miles away. Other popular activities for all campers were 6:00 a.m. fishing cruises, Saturday night plays or reading in the library, located in the upper Senior Boathouse. Some campers were in the camp's "Life Corps" (aka lifeguards). Junior camp's fire circle was at the far northern end of camp, near the present-day maintenance shop and the old "up and over" wall. A new dock was built, and the culminary writer notes that the camp ardently hoped for a brand-new camp program the following summer: sailing.

The culminary writer got his wish. In **1935**, the sailing program began at Camp Cory. Four new sloops were used; they were sixteen-foot K-class boats (and were probably rented). To assist with the new sailing program, the camp obtained a new outboard motorboat, new buoys, new anchors and new moorings. In athletics, the semipermanent teams of the "Penns" and the "Yans" were locked in a summer-long contest of skill. Mrs. B. Harris (relative to the eponymous Cory family) donated a set of chimes to camp. And we learn that the Senior Village fire circle was located near the present-day senior flagpole and the modern cabin S-8.

1936 was Camp Cory's second year of sailing. At the beginning of August, Cory skippers raced against the Chaumont Yacht Club. At the end of the contest, Chaumont beat the Cory skippers, who were after all still learning, seventy-two points to fifty-five. Cory sailors also raced amongst one another for the Tom Sharpe Cup, named after the ex-commodore of the Rochester Yacht Club who had won the Canada Cup and who was also a "friend of the camp." 1936's winner was Will Templeton, who later became sailing master in 1940–41 and program director in 1942. In addition to the four sloop-rigged sixteen-foot dinghies, the Cory navy consisted of four war canoes, two cruising canoes, twelve rowboats and one safety auxiliary craft. Campers built boats in the Cook building; held track and volleyball competitions in the fields; took long-distance swimming classes; and either read in the library, played music or acted in the dramatics program on the

upper level of the Senior Boathouse. Junior Village had a mascot in Violet, the pet sheep of one of the staff members, or possibly of one of Camp Director George Brown's family members (this was Brown's only year in that position). Any camper could have individual consultation and coaching during the activity periods—this was probably headed up by the "Guidance Department." For many of these early years, camp had a program director, social director or guidance director. To some degree they appear to have been interchangeable, and at other times it seems as if the program director supervised camp activities, the social director supervised religious events or "social" events like all-camp games and the guidance director focused on the growth and development of the boys.

The **1937** culminary was dedicated to Schuyler Wells, who had been a junior leader in the early 1920s. This summer marked the twenty-first year of the Bonesteels working in the kitchen (Gus and "Ma" would continue there until 1943). A new camp director, Bill Briggs, took over operation of the camp and would see it through most of the turbulent years of World War II. The camp received four new K-class dinghies that summer, and the experience that the campers had gained since the previous summer paid off: Cory won two inter-camp regattas. The camp also appears to have hosted the "Cory Challenge Cup," a K-boat regatta won by a man from the Kohinoor Yacht Club (K-boats were very prevalent on Keuka Lake in those days). Beginner swimmers were known as water puppies and could then progress to egg, tadpole, shark and eventually whale. The swim instructors focused on the front crawl; the culminary makes special mention that no trudgeon, side or other "fancy" strokes were taught. The *Cory Cackle* was founded, replacing earlier iterations of the camp newspaper; it sometimes contributed information for the camping column in the Rochester *Democrat & Chronicle*. Campers began taking long canoe trips to Seneca Lake. These "Seneca Trips" likely paddled down the Keuka-Seneca Outlet Canal and established a "base" below Glenora—it was a twenty-four-mile round trip. We also learn of a new honor society at camp: the Sons of Cory. A select few senior campers were chosen each session to become a Son of Cory, and they remain proud to have been selected, even to this day. Finally, the culminary notes that Junior Village started its Sunday ceremonies in an odd way: by chanting "Waconda." This may very well be the first appearance in Cory history of that great god of fire and light.

The Camp Cory Annals

Bill Briggs.

A Sons of Cory ceremony, late 1930s.

During the **winter of 1937–38**, the *Cory Cackle* put out a Christmas issue. It notes that camp cost three dollars in registration fees and twelve dollars per week of camp. Wednesday was the first day of a period, and camp would run two four-week periods the following summer. More importantly, the *Cackle* noted that trucks and diggers had filled in the Senior Beach, making it possible to erect cabins down on the waterfront. Lastly, future campers and staff were informed that Senior Camp would be split into three villages. Until this point, random tents in Senior Village had been converted to cabins one by one, but now all of the remaining tents were to be replaced. Cory was a camp of cabins now; the era of tents had ended.

The **1938** culminary reiterated that there were eleven new permanent cabins at Cory and added that one hundred new maple trees had been planted in Senior Camp. Both sides of camp now had new toilets, washrooms and sources of drinking water. Camp also had a lathe, a drill press, a power jig saw, a pottery kiln, fifteen new canoes, fourteen rowboats overall and six sailboats overall. In late July, Cory hosted the Cory Invitation Regatta. Participants included fifteen K-boats and four miscellaneous craft. Cory skippers won second, third, fifth and seventh place. Camp had a photo club, but camper participants were required to supply their own film and cameras. Camp also added a novel activity: horseback riding! The horses were located in a field next to camp, and the program had 150 overall participants. The camp circus had rope walking, pyrotechnics, "living statues" (counselors in silver paint) and a parallel bar exhibition. Campers also took early morning bird hikes, learned astronomy, formed a weather bureau and even examined the bones of a horse (hopefully not one from the riding program!). There was a "morning thought" given each day, likely at the dining hall. There were overnight hikes to Guyanoga and Watkins Glen, the Radio Club kept in touch with the sailboats on the water (as well as contacting Pennsylvania, New Jersey and Michigan) and in Junior Village Handicraft campers made leather and warrior regalia. Senior cabin campers, it is revealed, could go on a Seneca Lake canoe trip if all members of the cabin passed canoe and swim tests. Art Haskins, who ran the trips, informed Cory staff members decades later that the land used for these trips was borrowed from a local farmer. He recalled that campers had to be closely supervised or else they might break windows of buildings nearby. A mark of the leniency of the times, counselors would sometimes break into neighboring wineries to steal

The Camp Cory Annals

Right: For one aberrant summer, there was horseback riding at Camp Cory.

Below: The chapel, 1938.

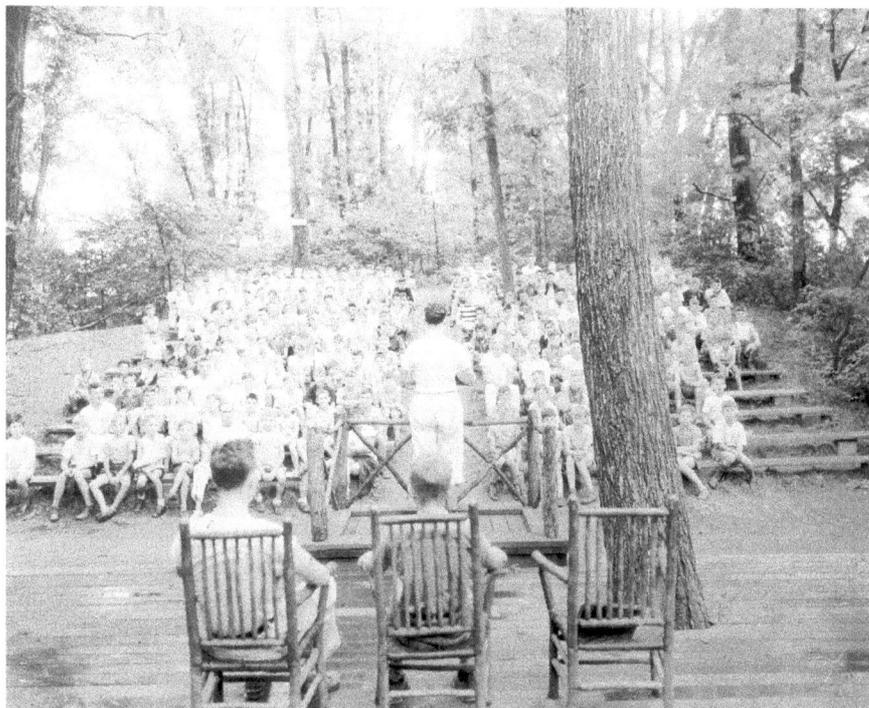

champagne. Haskins also noted that there were not very good camp/town relations, probably "because the counselors would steal all the girls away."

During the first week of **1939**, Harvey E. Cory passed away. The camp, forever indebted to his generosity, mourned the loss deeply. But life went on: junior campers played shuffleboard in their boathouse, two staff members each donated another dinghy to the fleet and Cory won all three of its inter-camp baseball games. Junior Village, likely in an attempt to compete with the Sons of Cory, introduced the "Red Feather," awarded to outstanding young boys. Campers continued to take Seneca trips, Keuka trips and trips to Watkins Glen. A weather station was set up. Stricter lifeguarding classes were introduced. Senior campers swam across the lake with their counselors. Most cabins were responsible for completing a work project of some sort. Tom Sharpe eliminations were held every two weeks (unfortunately, records of most of the winners, as well as the physical cup itself, are lost). This summer, there was a Senior Village director, a Waterfront Village director (George Kaiser) and a Walmsley Village director (Orrin Van Dyke). This is the beginning of Walmsley and Waterfront Villages. There were seventeen senior cabins overall (maybe only sixteen, since in those days "thirteen" was often skipped), with thirteen or fourteen up in Senior Village and the remainder on the Waterfront, but it is hard to tell where the Walmsley boundary line was. Van Dyke lived in Cabin 10. At the time, however, it would seem that Walmsley Village was on the south side of the lower athletic field, where Wells is now. (It was switched to its present location sometime in the 1970s.) Waterfront Village had three cabins. Walmsley Village was named after J. Milnor Walmsley and his wife, who had both been involved in boys' work in Rochester for some time.

In fact, the **1940** culminary was dedicated to Mrs. J. Milnor Walmsley. Seneca trips continued this summer; Cory staff took trucks eighteen miles to "Bascum's Point" in order to establish kitchens at the campsite. This year, the trip consisted of a nine-mile paddle to Glen Eden, setting up a temporary camp, hiking to Glenora and swimming in some of the pools there. Boys who did exceptionally well on the long canoe trip were known as "Acenes." Other campers participated in a longer canoe trip, leaving Monday, returning Wednesday, leaving Thursday and returning again Saturday from Camp Arey Phelan. Sailing was beginning to develop a crew

ranking system: campers were either novices, midshipmen or seamen. There were twenty K-boat races over the course of the summer, including those for the Tom Sharpe eliminations and those for the Keuka Yacht Club Trophy. It is clear from the culminary, and its mentions of where certain campers lived, that sailors were not at this time housed solely in the Waterfront cabins. It is also apparent that a Rochester scout troop lived at camp for the first two weeks, possibly on their own, with activities separate from other campers. Trips continued to Bluff Point, and campers were also known to visit the Penn Yan Boat Factory in the village or to go on three-day hiking trips. Junior campers would go on pre-breakfast bird hikes, and campers in J-10 ("fire-light lodge, the newest cabin in Junior Camp") went on an all-day trip to Red Jacket Park.

In **1941**, the camp had a total of eleven sailboats, four of which were new: an eighteen-foot Sea Gull, two "snipes" and one "cat boat." The Tom Sharpe Cup, we learn, was awarded to the best sailor of the summer, while another trophy, the Cory Regatta Cup, was awarded to the last race winner of the summer. Down on the Waterfront, the camp switched from Red Cross to YMCA lifesaving and adopted the motto "Every camper is a swimmer." The Craft Department included many subdepartments, including archery, photography, metalworking and model airplane building. Athletics included badminton and horseshoes, shuffleboard continued in the Junior Boathouse and campers even played cricket from time to time. One Sunday night, the junior camp counselors played softball against the senior camp counselors. Nature class started a snake pit, which by the end of the summer included about thirty snakes because it had become a "maternity ward." The class also built pens for pet ducks Duke and Duchess, four guinea pigs and four pigeons. Nature class also built a natural aquarium, learned butterfly mounting, took canoe trips to the Penn Yan Swamp, studied the stars, did microscope work and took weekly overnights to Watkins Glen State Park. Boys in Waterfront Village took trips to Canandaigua Lake. The campers also became cultured in the ways of music: there was a Cory band, a Hill Billy Band, a chorus that sang at chapel and a Sunday night music appreciation class where boys listened to classical music. For some trips, a truck took campers to a base camp on Seneca Lake or twelve miles south on Keuka Lake, where a dock was built. Scout troop 20 occupied cabin S-11 during weeks three and four; there was no cabin S-13, nor was there a J-13.

Most senior camp cabins, again, did work projects, such as building floats or signs for cabin numbers. Junior camp, it turns out, had separate chapel services, at least for this summer.

In **1942**, the sailing rank of skipper was added to the already existing cabin boy, midshipman and seaman. Sailing activities were held through the "Cory Corinthian Yacht Club," run by Commodore Larry Fitch, a camper who held the rank of skipper. Campers could race for the Tom Sharpe Cup, the Cory Regatta Cup and the "Viking Cup." Overnight canoe trips were taken, like in previous years, to a spot ten miles down the lake. There were overnight trips to the Bluff, as well as daylong trips that departed at 8:00 a.m. and returned by suppertime. The photos in the 1942 culminary are noteworthy for the lack of houses along the Keuka shore. The Garrett Chapel, located at the Bluff, had a "continuously-playing" pipe organ that campers would see on trips there. Athletics ran both day and evening programs, and campers who were advanced swimmers (i.e., those who could pass a 220-yard swim test) took lifesaving class. The health supervisor helped to teach junior lifesaving, and only those campers who were seventeen or older could take senior lifesaving. This being the first summer during which the United States was at war, it is not surprising that the U.S. government had placed an emphasis on fitness. Athletics classes were stressed as an integral part of

Chapel with organ.

camp, and the Rogers fitness test was given to every new camper and every departing camper. The Handicraft Department produced numerous red, white and blue checkerboards to ship to America's soldiers. One particular Thursday, campers and staff set up for the carnival. The following day, the entire camp slept in and then began the circus at 1:30 p.m. Parents came to enjoy the festivities, including pie and ice cream concessions, and the event ended with a spirited singing of "The Star-Spangled Banner."

1943 was one of those rare summers in which no sailor joined the "rudders up" club (that is, no one capsized). Sailing races were held every Sunday, and cup races were all during the last week of camp. (It must be noted that, by this point, the culminaries gave much information about the sailing program. Perhaps it was because the program was still "new" or perhaps it was because sailing was seen as something rather unique among camps at the time.) For evening programs, campers sometimes watched movies in the Junior Boathouse, sometimes had a variety show and sometimes had individual cabin campfires. Popular games at the Cory Circus included "Be a Bombardier" and "Hang Hitler,"[3] and military music played throughout. The three Waterfront cabins ran the sideshow, which included the terrifying "wild man from Borneo." A reptile pit was sunk into a creek next to the lodge (aka the dining hall). Buddy chips were used down at the Waterfront, and buddy checks were conducted every three minutes. A 1943 tradition, surviving to this day, and likely in existence since camp's inception, was the morning dip, an "eye-opener" before breakfast. Lastly, as a sign of the times, the Craft Department suffered a shortage of metal throughout the summer. (I believe that this may mark the beginning of the transition from "Crafts" to "Arts and Crafts.")

The **1944** culminary was dedicated to all Cory staff and alumni in the armed services—it went on to list them all. In 1944, again, there were no sailboat capsizes. In what was no doubt a bizarre and exhilarating experience, lightning struck a tree behind the Senior Village Chapel. The Thunderbird totem pole, redesigned every few years due to wear and tear, was designed so poorly in 1944 that it was derisively known as the "Thunder Bug." Campers

3. "Hang Hitler" was likely a relatively common carnival game involving cans or some other stackable object. A two-dimensional pyramid would be made of the cans, with Hitler placed on top. Campers would throw projectiles such as bean bags at the cans, attempting to knock over enough to effectively "hang" the Hitler effigy.

took trips to the Penn Yan swamp and to the nearby airport, carved a fifteen-foot totem pole out of an old telephone pole and enjoyed attending a mid-season banquet. There were also morning vespers services, before reveille, in which two different cabins would participate each day.

1945's culminary was the second that was dedicated to Schuyler C. Wells, who by now was an influential member of Camp Cory's Board of Management. Bill Campbell replaced Bill Briggs as camp director this summer. Every morning at camp, after reveille, the morning cannon would be fired off, after which campers gathered around the flagpole, and then came the "morning dip" before breakfast. Cabin groups would build their own mini-chapels

The cannon was fired off every morning. The building in the background was the director's office until the late 1990s. It now holds athletic equipment and evening program supplies and is called the "Epo Depot."

behind their cabins or down by the Waterfront for morning and evening vespers services. It was during this year that Waterfront camp began to have its own separate campfires, meetings and vespers (in fact, during the war years, it is possible that villages briefly ceased to exist due to the shortage of staff; it is certain that counselors were younger than usual because of the unavailability of older men who were off at war). Waterfront Village also attempted a certain level of self-governance, electing its own village officers from the campers present. Over in Junior Village, a few campers were part of a merit system, wearing headbands with beads—a gold feather on this headband was the highest honor. Junior cabins paired off into "tribes"; these tribes did most activities together. In the Crafts Department, aluminum and copper could be used once again, thanks to the success of the war. The nature lodge zoo included alligators, skunks, mice, chameleons and turtles; courses were offered in frog and snake dissection. One week before the end of the summer, a new all-camp council ring was dedicated: it included a stockade, two fire altars and a thunderbird and was located just below the mess hall, where it remains to this day. Mid-season and post-season, campers could attend banquets at which the senior staff were the waiters.

Many changes came to camp in **1946**, the first post–World War II summer. The Cory Sailing Cup (perhaps another name for the Tom Sharpe Cup) was replaced by the William J. Dunbar Sailing Trophy. Presented by Mrs. C.B. Webb of Cleveland, the cup was named after a former camper who had been killed in World War II. Paul Kober, a camper in 1946, obtained four second-place finishes in order to have the honor of being the first name carved into the cup. This was also the summer when the Sailing Department first moved to the yacht club building, its current location. The communal washstands, admired by campers and staff through the early 2000s, were "new" this summer. Over in junior camp, the counselors were dedicated to making the campfires Iroquois-themed. During rest hour, the "Hoky-Poky man" delivered snacks to campers throughout the camp. Campers were inspected daily for cleanliness. One of the reasons for cleanliness inspections is evident in the nature program: the camp had a pet skunk, "Corny Jr.," possibly named after Corneil Balding, the senior camp director. Though we know few of the details, the culminary notes that camp held a funeral for the animal some weeks later. Many of the counselors were returning GIs who told great stories about their adventures on the other side of the world.

Campers took trips to Watkins Glen in the back of the camp truck, and junior camp invaded the Red Jacket beachhead, possibly at the command of some of the GI counselors.

In **1947**, a newer, longer, wider boathouse was built in Senior Village—there had been no such building the previous summer. The new boathouse was farther back from the shore and used some of the same lumber from the old boathouse. The camp obtained surplus rafts from the U.S. Navy for use in Junior Village and new headgear, fourteen-ounce gloves and bags for boxing. For some Tuesday night programs, campers would watch or participate in seven bouts of boxing, one of which even included a knockout! In another sign that woodworking and metalworking were being phased out, leather boondoggle was now proclaimed the most popular craft of the summer. This summer also marks the first time that the culminary explicitly mentions two-week sessions—before this, most campers were expected to come for four or eight weeks. It is also this summer that marks the first references to "Wells Village," named after Schuyler Wells, mentioned previously. The

Boxing was popular for decades, faded and experienced a revival after the release of *Rocky*. The metal holes for the boxing ring are still in the Senior Boathouse floor.

camp cabin-naming vernacular, by this point, had evolved to something very recognizable today: "Senior 12" or "S-7" were ways to identify cabins. Waterfront Village had two dances with Camp Onanda, a local YWCA camp—one dance at Cory and one at Onanda. Waterfront Village also took after-dinner canoe trips to Willow Grove, went sailing by moonlight and took trips, as a village, to the Bluff. Some of these trips, it appears, were not by sailboat but rather by war canoe, and the sojourners stopped at Keuka College for supplies. Although Waterfront Village was by now its own entity, it did not yet hold a monopoly on the sailing program: junior campers could obtain the rank of "skipper," and Wells campers raced for the Dunbar Cup.

In **1948** the entire camp's power system was rewired, and electricity ran into each and every cabin. Though modern technology was encroaching, now-embarrassing practices remained: for example, the Cory Minstrel Show was all done in blackface. Junior cabins were permitted to sleep out one night per two-week session in tents pitched in a glen next to camp (possibly the later-named "Sacred Glen" that marks camp's northern border). Another event that took place only once per session was the Sons of Cory fire. Campers sat at the central fire circle while counselors in white robes tapped the select few on the shoulders with swords. The 1948 culminary mentions "Chee-chee-o-pogwha," the god of weather who can, depending on his disposition, bring rainy weather or pleasant. Safety was also beginning to become a concern—a summer or two earlier, camp had accident insurance, and this summer there was both a focus on camper supervision on trips as well as twelve to eighteen lifeguards on duty at the waterfront. Camp also utilized a motor rescue boat to further ensure safety. Boxing took place every Friday; boys were "picked volunteers" and fought for three 1.5-minute rounds. The culminary, of course, stresses the emphasis on safety in the boxing ring. Campers played ball games against "JY camp," Camp Seneca and Camp Keenan from the Lockport YMCA. Crafts were mainly leather and small wooden trinkets, and boys had to pay for their own materials. If a camper passed a sailing test, he could obtain the rank of cabin boy. He could then progress on to seaman, mate or skipper. Only mates and skippers could sail their own boats, and only skippers could race for the Dunbar Cup. The sailboat races consisted of three-mile triangular courses, and more than twenty races made up the regatta. The Waterfront Village again held two dances with Camp Onanda, one home and one away. Waterfront campers

Polaris v. Corsair.

also attempted to canoe to Guyanoga (likely *via* Branchport) but were rained out and had to be carried back in the camp truck, "Genevie." Waterfront campers took canoe trips to the Bluff and went on eleven-mile hikes with ex–Army Ranger Mark Williams, the Waterfront Village director. Lastly, in a sign of the village's growing separation from the rest of camp, Waterfront Village often had its own evening programs.

The **1949** culminary was dedicated to the Old-Timers, an alumni group responsible for, among other things, constructing the bridge on the west side of the Cook building. On July 20 was the dedication of the Walmsley Lodge (the Senior Boathouse that survives through 2011). Modern Junior Village campers would no doubt be horrified to learn that their 1949 counterparts had two swim lessons per day! Every Saturday, Senior Village had a cookout, and every Sunday was a joint junior/senior council fire at which Sons of Cory were chosen. Waterfront campers helped with cleaning and maintenance;

they also took a trip to the Penn Yan Theater and once again had two dances with Camp Onanda. Waterfront campers, again, elected a mayor and a council to help in that village's self-governance. Popular evening programs this summer included liars' contests and "stunt night." Camp instituted a checkout system for general swim, and every counselor was expected to be on duty for that time. The Cory navy consisted of fourteen rowboats, more than twenty-five canoes and nine sailboats (seven K-boats, a Sea Gull and a "Sneak Box"). The Dunbar Cup regatta was made up of fifteen races—skippers received one point for starting, one point for finishing, one point for every boat defeated and one extra point for winning first place in any particular race. The sailing master had been in the U.S. Navy and had even visited the Antarctic in 1940. The Y-dock at the sailing waterfront was made of wooden uprights. Elsewhere in camp, a trip director scheduled three trips a week to places like the Bluff, Glen Arey and an area outside of Hammondsport. On one Bluff trip, five boys elected to walk back to camp while supervised by counselors from the boats, taking five hours. Boondoggle, again, was the most popular handicraft. Chapel services focused on Christ (unsurprising for a Cold War–era camp), and offerings were taken for Cory's sister camp, Camp Pelion, in Greece. It was during this summer that Camp Pelion sent a thank-you gift to Camp Cory: a white engraved rock that remains at camp today. There were three singing graces before each meal, and cabins continued having nighttime vesper services. Camp built a float for a parade in Rochester to dedicate a new playground. The Weather Club had the dubious honor of making more accurate predictions than the Rochester newspapers. Campers took early morning bird hikes beginning around 4:30 a.m., and boys enjoyed star talks at night.

The **1950** culminary was dedicated to the previous winners of the Cory Cup, an award usually given out to one camper per summer (though not given out certain summers) who best embodied the Cory spirit. Often the winner was also a Son of Cory. Camp also seems to have introduced "camp aides" this summer, who helped out with activities, work projects and firecrackers. Though New York State was not home to some of the harshest bigotry found during this era, it is nevertheless noteworthy that two African American campers attended Cory this summer (possibly the first two such campers in camp's history, though there had been some African American kitchen staff at Iola and during previous Cory summers). One of these boys

was a Son of Cory. Incomprehensibly, however, camp nevertheless put on another blackface minstrelsy show. A camp neighbor floated his boat across the lake on pontoons, with K-boats escorting it. Boys took trips to the Bluff, the State Forest Preserve and Clark's Gully, and there was even a three-day trip to Taughannock State Park for eight-week campers. It was also this year when Sam Johnson, the camp director, officially purchased the land at Guyanoga. The chapel bell was dedicated this year to Ed Harris Sr. (the Harris family being related to the camp's progenitor, Lieutenant Lawrence Cory). Waterfront Village again had Onanda dances, trips to see movies in town and its own sailing trips to the Bluff. According to the culminary, there were three skippers, eight mates, eighteen seamen and eighty-one cabin boys in the Sailing Department this summer. In the early culminaries, much space—pages even—was dedicated to talk of the Handicraft Department. It is therefore noteworthy that, in 1950, Crafts are mentioned in just one short paragraph: there was some silversmithing, and campers also worked with plaster, plastic and basket weaving.

The new land at Guyanoga was put to use frequently in **1951**. Apparently, Waterfront campers were commonly the perpetrators of various pranks at camp, including setting off firecrackers, ringing the chapel bell at night or stealing a village head's bunk. Every camper, young and old, was expected to participate in the soap bath at the waterfront every Sunday. A picture of this event is extant, although it would be inappropriate to include it in a book such as this, as campers commonly bathed nude. Apparently, girls would sometimes drive by on motorboats in order to catch a glimpse of the Camp Cory bathers and giggle. In other news down at the Waterfront, a new swim level was added: a "cork" was a camper who could float but could not swim. Elsewhere in camp, boys learned "horn-craft"; that is, using cows' horns to make things. Non-Protestants were still free to attend Mass in town on Sunday (and would continue to do so through the 1990s, when St. Michael's ended the practice). This year's culminary also makes clear that the cabin aides who had been helping for the past few years were essentially like modern junior counselors, although they may have been unpaid. This practice of having young counselor assistants in the cabins was to be a precursor for something that would come to fruition two summers later: the counselor-in-training program.

The Camp Cory Annals

The **1952** culminary was dedicated to, among others, Weldon "Chief" Hester, the camp director who had taken over in 1951. Hester would remain in this job until 1959, when he would help to found Camp Gorham in the Adirondacks. From 1960 or 1961 to 1972, Hester held the title of executive director of camping and oversaw both Cory and Gorham. At the time of the 1952 culminary, however, he was still but an exceptional camp director who had served as a Red Cross man in the Pacific Theater of World War II. This summer, Waterfront Village cabins each elected two "senators" to help plan the summer. The village went roller-skating, held dances with Camp Onanda, held boxing matches, watched movies in town, took trips to Keuka College and Willow Grove, played color war and played "Pirates and Spaniards." Sailing was still not the sole province of Waterfront Village, and Cory sailors raced in outside competitions at Hewitt's Point, Sunny Point and the Keuka Yacht Club. This year is the first that Junior Village was officially known as "Iroquois Village," a name that would last until 2003. Camp still had a real live person blowing the bugles from the flagpole every morning. Campers wrote stories for the new camp newspaper, the *Cory Cannon*. The Archery Department was now a subdepartment of Athletics, not Handicraft, as before. The craft program, in its now more diminished role, nevertheless

A pirate ship near Waterfront Village.

received new machinery. A new set of chimes was donated to camp and was used at chapel services. In thanks for all of the donations that had been sent to Camp Pelion, that camp named its infirmary for Camp Cory. One night, as a special treat, camp held a Galilean Service, at which the chaplain and choir were on boats with lanterns and spectators watched from the beach. At the Guyanoga campsite, some miles north of Branchport, campers used an old farmhouse as a lodge and rec room. After the season was over, three staff members led eight campers on an overnight trip to Kipawa Lake, three hundred miles north of Toronto.

1953 was the first year of Camp Cory's counselor-in-training program. Under the tutelage of the CIT director, aspiring counselors-to-be helped out with food service projects and with teaching activities. Although they may have been built previously, this is the first year we see evidence of the CIT cabins in the Senior Upper Athletic Field, where now stands the Mangurian Leadership Lodge. A new bridge was built behind cabin M-4, a new baseball infield was built in Senior Village, there was a new Star-class sailboat named *Nancy Ann* and there were new pole vault and high jump facilities. Sailors could take a three-day sailing trip, could race against the Keuka Yacht Club and in general found that the Sailing Program now had a revised testing program. Silversmithing was popular, as was leathermaking and smaller crafts projects such as ashtrays. The nature class caught three skunks and set traps for others. The camp store, this summer, operated as the bank, post office, refreshment stand and headquarters for "hokey-pokey" runs (see entry for 1946). The camp doctor visited camp every morning to inspect the walking wounded. After the season was over, staff members again led a small overnight trip to the northern parts of Canada, this time to Elk Lake.

The **1954** culminary remarks that it was the sixty-third camping season, indicating that the camp still counted 1892 as its founding date (this changed sometime before the 1990s). We also learn that the store/library used to be, at some point, in the back of the mess hall, at the south end of the building, where the staff lounge existed from circa 1954 to 2004. Chief Hester's wife, Happy, held the role of camp dietician. Boys took jaunts to Tal-e-po, Mosquito Island, Waunita, LaMoka and Canandaigua. Bill Hoth, the assistant director, fired the cannon every morning, and Wells Village had a cannon-shooting club. Chief Hester apparently had a large knife collection

that he sometimes displayed to the boys. The camp carnival was an attempt to raise money to send a Cory camper to an international YMCA meeting in Paris, France, in 1955. The chapel held sunrise services. After camp, there was another canoe trip to Canada, this time to "Ned's Island." On July 14, a severe windstorm knocked down several trees at camp, damaging the boathouse and S-15 (possibly modern M-2 or M-3). In his annual report to the Board of Management, Chief Hester describes his travels up to Penn Yan after the storm, helping people along the way. Once in town, he managed to get word to the Rochester YMCA that no one had been injured back at Cory.

In **1955**, the camp built a new blacktop basketball court in Senior Village. There was also a new waterskiing program, which was reserved for campers in the Waterfront Village. Boys took trips to Tail-e-po outpost (possibly on Seneca Lake) and the Erie Canal, and also took three-day canoe trips elsewhere. According to the culminary, at any given time there were two trips out. We also learn something of a camper's schedule in the 1950s: classes were in the morning, followed by lunch, rest hour and special activities in the afternoon (strikingly similar to the camp schedule in the 1990s through to 2002). This year is also the first time we see the Senior Village toilets referred to as the "Brown house," a name that survives to this day. According to Hester's year-end report, the infirmary was sometimes overflowing with campers suffering from a nationwide epidemic of strep throat. Campers had a new experience during meals: the availability of milk three times a day. CITs had a corn roast on the beach one night after "Taps." And the postseason canoe trip was growing: this year twenty-one people traveled to Anima-Nipissing Lake for nine days, traversing one hundred miles of wilderness.

In **1956**, on the first day of the summer, a giant wind blew the Junior Boathouse off its foundations; it was judged a total loss, and construction of a new building was soon in the works. This disaster couldn't deaden the campers' spirits, however; in the dining hall they enjoyed singing "after-mess songs" like "What Shall We Do with a Drunken Sailor," "The Weggis Song" and "Go Tell It on the Mountain." Sailing eliminations were held in much the same way they are today: regattas were held every two weeks, and the winners were invited back at the end of the summer to compete. The tennis tournament was held in the same fashion, and the 1956 winner was a camper who traveled all the way from Egypt to prevail over the other

Coryites. Waterfront Village took many trips to "the store" at Willow Grove, among other places. On Paul Bunyan Day, the camper who successfully made it to the top of a greased pole would be the winner of five dollars. At some point during the summer, camp had pet monkeys in a cage (though it is unknown whether these were brought for one day or for a longer period of time). In a rare decision, the Cory Cup was not awarded to any camper this year—as the culminary puts it, the staff were impressed with the campers but "they were not sufficiently mature in their action to warrant the Cory Cup." Camp welcomed a new motorboat launch at the Senior Waterfront, as well as new "Brown house" facilities in Junior Village (which would later become known as the "Whispering Pines"). More postseason trips were taken to Ned's Island in Canada, where two log cabins functioned as a "base" for extended canoe and fishing expeditions.

The year **1957** saw a new Junior Boathouse with a new sandstone chimney; there was also room in the basement for a shop and for storage. Camp obtained new K-boats with fiberglass decks, replacing some of the old, wooden Ks. CITs, ages fifteen and sixteen, would attend for two years. During their first year, they would alternate sessions living on the hill in their cabins and working in the dish room. Second-year CITs alternated sessions living on the hill or acting as stewards in the dining hall. After the first session of camp, two exceptional CITs were sometimes chosen to become counselors for the remainder of the season. CITs took trips to Geneva, Palmyra and Skaneateles and were only encouraged to apply for a job as a counselor the following summer if they could "handle" it. CITs sometimes, it seems, lived in cabins with counselors. In 1957, for the first time, Cory ran a "gypsy caravan camping program," in which a small group of campers toured New York City, Washington and the Gettysburg battlefield. Back at camp, Iroquois Village, true to its name, focused greatly on Indian lore, even appointing an Indian lore director to oversee activities beneath the village director. Wells Village had a dedicated overnight camping site at Five Mile Glen and often took late evening dips just before "Taps." Walmsley boys traveled to Tail-ee-po, Sugar Hill (near Watkins Glen) and Seneca River; they also enjoyed sailing along with the Waterfront campers (perhaps Wells and Iroquois boys were now excluded from this program). There were new steel docks in Junior and Senior Villages, with wooden pallets atop; this type of dock would be familiar to any attendee of camp through 2003. During the

fourth period, the Trip Department put on "Paul Bunyan Day," in which all camp activities were geared toward outdoor techniques, like splitting wood or fire building contests, and woodsmen games like the "monkey walk" on ropes. The chapel received a new organ and often hosted visiting chaplains and speakers. The Mike Maijgren Cup, awarded to the most improved sailor of the summer, was new this year and was awarded to a Walmsley skipper.

1958's culminary was dedicated to Mr. Gunter Heymann, the artist who created the murals in the dining hall that still exist today. A retaining wall was built at the Junior Boathouse, and dirt was filled in behind to allow direct access to the boathouse porch. Gary Diehl assisted at the Waterfront as a second-year CIT. He would go on to become junior Waterfront director in 1960–61, and an award for camp's young leaders would be named after him more than a decade later. Cory's fleet of seven K-boats raced matches against

Painting the dining hall murals, circa 1956.

105

one another as well as at Keuka Lake regattas and Rochester Yacht Club events. Trips continued off camp under the auspices of the Trip Department. Doors and shutters were installed on the last of the camper cabins; they could now all be completely enclosed if desired. These appear to have been idyllic days for Camp Cory, perhaps due to the baby boom. Camp's 226-bed capacity was always filled, and improvement projects continued, unabated, throughout the late 1950s and early 1960s. One exception to this was the "trip caravan" program mentioned previously; it was canceled this year due to low registration. Though this history focuses largely on the summer camping aspect of Camp Cory, it is worth noting that during this era spring and fall weekends were also filled up with programs such as Indian Guides, Hi-Y training camp, Family Camp and Cornell Training Camp.

In **1959**, the Johnny Loock Memorial Council Ring was dedicated; it stands in Junior Village still. John Loock was a junior Waterfront director and junior camp director who was killed while flying an experimental aircraft in California. His ashes were scattered at the Garrett Chapel on the Bluff, where a memorial to him was placed. Night swimming lights were added to the Junior Boathouse porch, wooden railings were built at the entrance to Junior Village and the Indian sign language paintings—familiar to some alumni—were drawn in the dining hall by the now-famed Gunter Heymann. Camp had a special themed day each period this summer. First period had the carnival, where the favorite booth was the CIT spook-house. Second period had International Day, third period had a water carnival and fourth period had Paul Bunyan Day. In addition to Sunday chapel services, each village had a vesper service once each two-week period. There was also a new program this summer: the Ranger Trips. Each period a group of campers took a ten-day trip into the Adirondacks or Canada. Cabins were inspected each morning, and cabins "which couldn't quite meet our standards of inspection" were given a "GI party," where *every*thing would be taken out of the cabin and placed in the field outside. CITs, apparently, had to be invited to join the CIT program. Chief Hester included demographic numbers in the back of all of his year-end reports: in 1959 by far the largest number of campers came from the town of Brighton (196), followed by Rochester (162), Irondequoit (122), Pittsford (38) and Webster (33). In this report, Hester ends with "closing thought...the 1959 season was a good one."

The Camp Cory Annals

The Johnny Loock Memorial Council Ring. According to his widow and alumni who knew him, John Loock was rarely, if ever, called "Johnny."

One "float" at the Water Carnival.

Carl Alford was the camp director in **1960**, likely because Chief Hester was busy in the Adirondacks preparing Camp Gorham for its first camping season the following summer. Lifeguards at the Senior Waterfront utilized a two-story float, as well as guard chairs that are all too familiar to recent and current Cory staff! A third tier was added to the fire circle in Junior Village to help hold the large number of boys. Junior Waterfront Director Gary Diehl, either this summer or the following one, reputedly leaped off the end of the junior dock and swam the entire length of Keuka Lake. As an aside, an advertisement in the back of the 1960 culminary is for none other than staff and camper favorite Seneca Farms Ice Cream!

Chief Hester returned as camp director in **1961** (although the culminaries had long been listing his title as the more cumbersome "Director of Camping"). It is likely that, while being director at Cory, he was also considered the director of camping services at the Rochester YMCA, which now also included Camp Gorham. Campers still marveled that such a small cannon could make such a loud noise every morning. Wells campers took overnight trips to "Enos Farm." Walmsley campers enjoyed boxing and wrestling matches (on a mat, of course) in the boathouse. "The oldest boys," says the culminary, "live in Waterfront Village and enjoy a very casual and interesting program." Indeed, Waterfront boys spent their first three days on trips around the region and had dances not only with familiar Camp Onanda but also with new and exotic girls from the Elms, a girls' camp near Hammondsport. Special days this summer were very similar to previous years, except with the addition of "wild west day," which included a reenactment of Custer's Last Stand and a revue at the "Red Eye Saloon," MC'd by Eric Bellman, John Behee and Gary Diehl. Paul Bunyan Day, the fourth-period special day, was now "one of Camp Cory's oldest traditions." Ranger trips continued into the deeps of the Adirondacks and the White Mountains of New Hampshire. These trips would continue in later years, but under the auspices of Camp Gorham. Some pages in the 1961 culminary are dedicated to the new Adirondack campsite and invite campers to be "Camp-Makers" who would prepare Gorham in 1962 for the arrival of real campers in 1963. Camp-makers were required to be high school students, ages fourteen to eighteen, and were required to weigh more than 125 pounds. "We'll want 40 to 60 fellows for each two week period, fellows who are rugged and in good condition. We cannot have younger or lighter weight fellows who may strain themselves and overdo physically."

Above: Boys marveled that so small a cannon could make so loud a noise. It was briefly stolen in the early 1990s before being returned by an anonymous benefactor (or the anonymous malefactor).

Right: Later culminaries went to great lengths to describe the safety mechanisms in place for activities such as boxing.

The **1962** culminary was a joint Cory/Gorham book. Chief Hester was now certainly the director of camping for the Rochester YMCA as well as the resident director of Camp Gorham. Camp Cory welcomed a new resident director in Allan M. Finkle, who had been the associate director in 1961. By this summer, and the previous summer as well, Iroquois Village operated as an entity completely separate from the rest of camp; this continued until 2002. Iroquois had boys ages eight to ten and a half, Wells had ages ten and a half to twelve, Walmsley had ages twelve to thirteen and Waterfront had ages thirteen to fifteen. Wells boys spent their free time playing roof ball, then "a game quite new at Cory." Walmsley boys often took two-day canoeing or hiking trips to such places as Seneca Lake, Letchworth State Park or Robert Treman State Park. Waterfront boys were known to have "greased watermelon fights," no doubt similar to the ones that continued into the twenty-first century. Even at this early date, Camp Cory claimed to have the world's largest fleet of K-boats, a boast that would last decades. Ranger trips traversed the wilderness in Canada, New Hampshire and New York, even stopping over at the fledgling Camp Gorham. Several pages of the culminary are devoted to the successes of the Gorham camp-makers program and to the planned programs for 1963. It is at this point that Gorham began to operate as its own, separate camp and is therefore the point at which that marvelous camp must depart from these pages.

The **1963** culminary is peculiar in that many of the passages mentioning the villages, or the "a typical day" section, are almost word-for-word reproductions of the previous year's passages. Small details have been changed, but it appears either that Cory was largely the same this year as the previous year or that the culminary was a rush job, or both! After flag raising, the entire village would engage in a short spell of physical training. The Dunbar Trophy, once again, was won by a Walmsley camper— a clear indication that sailing was still not limited to those campers in Waterfront Village. The special days for the summer were, in order by two-week period, Wild West Day, International Day, the Water Carnival and Circus Day. Ranger trips were now solely the province of Camp Gorham.

The **1964** culminary was the last to be printed until 1989 and the last to be printed with significant text descriptions until 2003 or 2004. Like its recent predecessors, this culminary was devoted to both Camps Cory and Gorham.

The Camp Cory Annals

The writer of the book, again, seems either pressed for space or for time. Activities and villages were given only cursory descriptions; for example, all we learn of Wells is: "George Parsons competently manned the helm in Wells Village. Its program was much like that of Walmsley except for the exciting over night trips to Tail-ee-po and Enos' farm." A picture of the Junior Boathouse (known as the "Longhouse") reveals a large head hanging over the entrance. The culminary relates that this is "Chiciopaqua, our rain god," although some alumni and outsiders claim that the relic was actually "obtained" from Camp Iroquois, another camp down the lake. The Junior Nature Lodge is noted as "the most recent addition to camp." Although only a photograph of the interior is given, it appears to be the same building that later became the Arts and Crafts lodge and burned to the ground circa 2005.

<p style="text-align:center">✳✳✳</p>

So end the culminaries that tell of Camp Cory's history. As mentioned previously, photo-filled yearbooks would resume in 1989, and complete culminaries resumed in 2003 or 2004. A brief review of the developments occurring after 1964 is due here. The events that occurred in the years between 1964 and 1989 could no doubt fill a whole volume. Perhaps one day they will.

FURTHER DEVELOPMENTS

Two years after Director Bob Smith, Neil Gray—a former CIT director, Junior Village head and program director—became Cory's camp director. He would continue in that role until 1974, his last summer. Off-camp trips remained lax through the 1970s and possibly later: campers would simply hop in the back of the camp truck, and off they would go. In 1969, an off-camp trip needed the truck driver to come pick up the campers, but he told them they had to wait—that evening a large group of staff had gathered in the infirmary to watch the Apollo 11 moon landing. Counselors in the late 1960s and early 1970s would listen attentively to the radio on a near-daily basis, anxious for their military draft numbers to be called.

By the late 1960s, the Waterfront Village had become a specialized sailing program for which campers had to sign up specially. The name of the village vacillated back and forth between Sailing Village and Windjammer Village before finally settling on Maijgren Village in 1971. The village was named for Henry T. "Mike" Maijgren, the former camper, bugler, nature study director, storekeeper, camp secretary and member and chairman of the Board of Management. The Sailing Program "glassed" several of its old wooden K-boats in the 1960s to make them more maintenance-free. Murray Wright of Dundee, New York, built K-boats, named for the Kohinoor Diamond, from the 1930s to the 1970s. Some remain at Cory still.

Chief Hester remained executive director of resident camping for some years; his last summer was 1972. Before he left, Hester wrote a booklet to his successor, *Information on Aspects of the Rochester Y.M.C.A. Resident Camping Program for my Successor, December 1972*. This booklet is an invaluable source of information for certain developments that occurred at camp before Hester's departure. It also includes some information that Hester apparently wrote in 1960, when he first stopped working as resident director of Camp Cory. The Committee of Management, which used to supervise only resident camps, would in 1972 begin supervising all camps in the Rochester association. The director of camping would report to the assistant executive director, responsible for programming in the Rochester Y. Most of the food service in Hester's time was handled by the Serv-Rite Food Corporation. Hester writes to his successor, who ended up being Roy Tulp, "Sons-of-Cory is truly traditional. Another system might well be a better one. Decide for yourself." And so Tulp did decide, eliminating the Sons of Cory system from the camping program. It is clear from Hester's booklet that he was not a fan of excessive awards and sometimes quarreled with committee members who had attended camp when it had "an exhaustive system of awards."

Hester describes other aspects of Cory camping, such as a golf trophy and archery certificate awards. He also beseeched his successor not to sell Guyanoga, as "roughing-it" camping was in limited supply for Camp Cory. Barbara Fisher, the director of Camp Onanda, had worked well with Neil Gray to continue the Onanda/Cory events (Fisher later became executive director after Roy Tulp). Jerry Enos, the Cory caretaker, had an emergency key and a key ring that would allow him to open any door in camp; he had strict orders not to allow anyone to use it, not even the resident director.

In 1975, it became apparent that Neil Gray would not be returning to camp that summer. Charles "Jerry" Elliott, who had been hired as Waterfront director, was promoted to the position of camp director. Jerry remained in this role from 1975 until 1996, and his wife, Liz, held the position of business manager throughout this time. Jerry is by far the longest-serving camp director in Cory's history. He worked summers at camp while teaching during the year near Syracuse, New York, and devoted hundreds of volunteer hours to interviewing and hiring staff. Jerry made some significant changes to camp: he had to replace many of the cabins in Junior Village with larger ones because of changes in New York health law (one of the smaller cabins was, as of 2010, still being used as a shed by one of Cory's next-door neighbors). One cabin located in Junior Village was pushed out over the ice one winter to become M-5, part of Maijgren Village. Jerry also changed the night-out schedule; before his time, a counselor's night off would last until the cannon

Appointments of Resident Camp On-Sight Directors

Jerry Elliott John Steinbrenner

Barbara Fisher, Director of Camps of the YMCA of Rochester & Monroe County has announced the appointment of Jerry Elliott of Syracuse, N.Y., as the on-sight director of Camp

Lawrence Cory and John Steinbrenner of E. Rochester, a member of the Physical Education staff of the Penfield School System, as the on-sight director of Camp Gorham.

Elliott and Steinbrenner are returning as directors of those two camps.

Registrations are now being accepted for the summer period at the above camps and may be made by contacting the Y Camp Office at 100 Gibbs St., Rochester, 14605

Inquiries may be directed to the Camp Office 325-2880, or at any of the nine branches of the Y*CA of Rochester & Monroe County.

Jerry Elliott (left), camp director, 1975–96.

Jerry Elliott with Tim Wilson (*center*, waterfront director 1974–76), Dave Knittel (*left*, Iroquois Village head 1976, program director 1978–79, 1981–82, CIT director 1985) and Jerry's daughter Melissa.

shot off the next morning, but now they had to be back by about midnight (this midnight rule became very strict by the 1990s). Jerry also helped to invent the "Code Red," a Waterfront emergency drill in which almost every counselor runs down to the Waterfront and searches for a missing camper (or a brick, as is most often the case). Around 1976, Wells and Walmsley were in their present locations (Wells on the south and Walmsley on the north), but at some point they switched. Jerry then thought it prudent to switch back, as it was not wise to have the older campers near the edge of camp with the backs of their cabins facing an unsupervised area.

This worry about nighttime hijinks brings up the most major change that occurred under Jerry Elliott's leadership: the admission of girls in 1976. As Jerry himself puts it:

It was the mid-70s and lots of institutions were addressing opening up more opportunities for women and girls. Enrollment was weak in '75, my first season. There was even some talk of putting all resident camp activities

The Camp Cory Annals

up at Camp Gorham and perhaps putting Cory on the market. There were more and more things for children to do summers besides traditional camp compared with earlier decades. The baby boom had run its course and the demographics were that fewer children were of camp age than in the 60s. Elementary schools were closing in many communities due to falling enrollment. Many camps closed as well.

Going coed was a social trend that many of us supported and it was hoped that it might help Cory weather the times. I think it did. It seems we had 3 women counselors that first coed year. Though I don't have the number of girls that attended that first year…perhaps the 3 women counselors were busy for the 4 two week sessions with 4 or 5 girls each. The girl campers might have numbered in the 30s and more.

…They stayed in junior camp and we divided the shower house and toilets to serve their needs. We integrated them into the program activities smoothly as I recall.

After more than twenty years of running camp, Jerry hung up his spurs. He was replaced in 1997 by Ellie Orbison, who was also the new executive director. In 1998, Michele Rowcliffe (née Weiss), former director of Camp Hough, took over as Cory's director. That same year, camp switched to one-week sessions to allow more campers to enroll, and Maijgren Village received its first JY-15s, smaller boats more conducive to competitive racing. Michele left to work at the Southeast Family YMCA in Pittsford in 2001 and 2002. In 2001, Ellie was once again camp director, and longtime staff member Dave Ghidiu took over running the camp most of the time as assistant director. By 2002, Dave and Ellie had both moved on (though Dave later returned in other roles), and at the same time Cory and Gorham were each split into their own branches—there would now be an executive director at Cory and one at Gorham.

The new director at Camp Cory was Rick Coyle, who had previously worked at Camp Seagull. He made many key changes in the camp schedule, most notably in staff time off and in the activity schedule. Whereas before one or two staff members were assigned to watch an entire village from 10:00 p.m. to midnight (an arrangement called "line"), now counselors were in cabins or on cabin porches unless on their scheduled time off. The daily schedule changed: there were now two activity periods in the morning and two in the afternoon, where before all four had been in the morning. Staff members, too, were assigned a specific activity area in which to work (similar

YMCA Camps to Admit Girls

By DOLORES ORMAN

The YMCA of Rochester and Monroe County announced today that it will accept girls at its two camps beginning next summer.

The camps are Gorham, located in the Adirondacks on Dart's Lake near Old Forge, and Cory, just below Penn Yan on Keuka Lake. Each camp has a capacity of 200 at any one time.

The board approved this major departure from the historic boys-only tradition "to keep pace with branch unit service to all members of the family established in 1973," said James Duffus, board chairman.

Duffus said that YMCA programs for girls have developed rapidly in suburban as well as city branches and that the total number of girl participants now equals boy participants.

He said that by providing full camping services to girls, the YMCA is thus offering a full, complete program of services to girls.

Asked to comment about the YMCA announcement, Pat Collins, director of the YWCA's Camp Onanda, said the YW had no plans to accept boys at its camp located on West Lake Road

near Canandaigua Lake. She said she didn't feel the change in policy would affect the YW's camping program "to any great degree."

"We still stand on our belief that a centralized residence camp for girls is still needed," she said.

She said that she "personally" thinks a boys' camp is still needed also. There is a "special type of interaction and personal growth" that can be achieved at boys' and girls' camps that cannot be achieved in a coed setting, she said.

Al Miller, YMCA vice president for communications and development, estimated that the YMCA serves about 6,000 children and that 50 per cent of them are girls.

William Blackmon, chairman of the YMCA's Metropolitan Camping Committee, said both camps are now ready to serve both boys and girls and no major renovations are needed.

Cory, on a 72-acre site, was founded 56 years ago. Gorham, which was purchased in 1961 for more than $200,000, is on 1,100 acres and bordered by state land.

Camp Cory began admitting girls in the summer of 1976.

to the first few decades of camp) as opposed to working in many different activity areas. An activity chief ran each program area. Mark Dibble, program director in 2002, helped to implement these changes and often acted as a de facto camp director.

In 2003, Michele Rowcliffe returned to camp, this time as executive director. Her husband, Shawn, joined her as the camp ranger. Mark Dibble was the camp director (though his official title was assistant director or program director, and in 2007 he became associate executive director). Iroquois Village was renamed Craig Village after Jean Craig made a donation in honor of her husband, Wilmot Craig, a former Rochester YMCA Corporate Board chairman. Over the course of a few years, all of the cabins in camp were refurbished to be more enclosed and secure. In one more big change, all swimming activities were moved to the Junior Waterfront in 2003, partially

The Waddy Sykes Boardwalk, constructed in 2005. The small building at center is the Wheelhouse, where currently dwells the camp director. The executive director now lives in a cabin near the Junior Waterfront.

The Leadership Lodge, completed in 2005.

Camp Cory built a climbing tower in 2003 and built a high ropes course in 2008 on the site of the old Arts and Crafts Lodge, which had burned down.

Autumn 2004, the CIT cabins are destroyed to make room for the new Leadership Lodge.

to allow easier access should emergency vehicles ever have to drive down to the beach. At Junior Village was a new floating metal dock, and at Maijgren was a new floating plastic one. All canoeing and kayaking now took place at the Senior Waterfront. In 2005, the dining hall was renovated (although the traditional murals were kept), the staff lounge was moved to a separate building, the CIT cabins were replaced with the Leadership Lodge and the Waddy Sykes Boardwalk was constructed between the Maijgren beach and the Junior Waterfront. Day camp, which had been a postseason activity in 2003 and a two-week program in 2004, was in 2005 a camp activity that lasted all summer and into the postseason. Day campers headquartered at the Miller Pavilion, located where one of the tennis courts had been previously. Mark Dibble adroitly directed Camp Cory during these years of renewal and development until finally finishing up in 2010.

The facilities and the people at Camp Cory have changed much over the years, but the camp's spirit has not. It is still a separate world of magic, laughter, the big, wide, starry nights and lifelong memories—hazy memories they are, but strangely beautiful.

So ends this history of Camp Cory. We are lucky that so many historical documents survive—I strongly advise any interested parties to read documents or look through pictures. They are strewn about the region, whether at the Rochester Public Library, the library at the University of Rochester, the "vault" at the camp's downtown office or at Camp Cory itself.

MODERN SONGS AND STORIES OF CAMP CORY

SONGS

"Alive, Awake, Alert, Enthusiastic"
(Repeat 3 times, faster each time.)
I'm alive, awake, alert, enthusiastic
I'm alive, awake, alert, enthusiastic
I'm alive, awake, alert,
I'm alert, awake, alive,
I'm alive, awake, alert, enthusiastic

"Announcements Song"
(Sung whenever a staff member utters the words "announce" or "announcement" in the dining hall.)
Announcements, announcements, announcements! Hey!
A terrible death to die, oh, a terrible death to die, oh
A terrible death to be talked to death, a terrible death to die
Announcements, announcements, announcements! Spell it!
A-n-n-o-u-n-c-e-m-e-n-t-s!
Announcements, announcements, announcements! Hey!

"Bananas, Coconuts and Grapes"
(This is a "repeat after me" song.)
I like bananas, coconuts and grapes!
I like bananas, coconuts and grapes!

I like bananas, coconuts and grapes!
That's why they call me Tarzan of the Apes!
I like hoo-uh! *(grunt and flex)* and coconuts and grapes! (3x)
That's why they call me Tarzan of the apes!
I like hoo-uh! and hoo-uh! and grapes! (3x)
That's why they call me Tarzan of the apes!
I like hoo-uh! and hoo-uh! and hoo-oo-ugh! (3x)
That's why they call me Tarzan of the Apes!

"Bazooka Bubble Gum"
(This is a "repeat after me" song.)
My mom gave me a penny
She said go eat at Denny's
But I didn't eat at Denny's
Instead I bought some bubble gum
Bazooka zooka bubble gum
Bazooka zooka bubble gum
(Nickel—buy a pickle, dime—buy a lime, quarter—buy some water, dollar—
buy a collar, five—stay alive, seven—go straight to heaven)

"The Bear Song"
(Repeat after me, then re-sing each verse all together.)
The other day
I met a bear
A great big bear
Oh way out there

He looked at me
I looked at him
He sized up me
I sized up him

He said to me,
"Why don't you run?
I see you ain't
Got any gun"

And so I ran
Away from there
But right behind
Me was that bear

Ahead of me
There was a tree
A great big tree
Oh glory be [or, "Oh lordy me"]

The nearest branch
Was ten feet up
I'd have to jump
And trust my luck

And so I jumped
Into the air
But I missed that branch
Oh way up there

Now don't you fret
And don't you frown
'Cause I caught that branch
On the way back down

That's all there is
There ain't no more
Unless I meet
That bear once more

[And I did meet
That bear once more
And now he's a rug
On my kitchen floor.]

The end the end
The end the end

The end the end
The end the end

"Brian Grogan's Goat"
(A "repeat after me" song.)
Brian Grogan's goat
Was feeling fine
He ate three shirts
Right off the line
Brian Grogan said
"This goat must die!"
So he tied him to
A railroad tie
Around the bend
A train grew nigh
Brian Grogan's goat
Was doomed to die
He gave three grunts
Of awful pain
Coughed up the shirts
And flagged the train

"The Cannibal King"
The Cannibal King with the big nose ring fell in love with a fair young maid
And every night, by the pale moonlight, across the lake he came
With a hug and a kiss (kiss) for his pretty little miss under the bamboo tree
And every night, by the pale moonlight, it sounded like this to me
Bah-rhoomp (kiss, kiss) Bah-rhoomp (kiss, kiss) Bah-rhoomp ah-dee ah-dee
aaaay
Bah-rhoomp (kiss, kiss) Bah-rhoomp (kiss, kiss) Bah-rhoomp ah-dee ah-dee
aaaay
If you'll be M-I-N-E mine I'll be T-H-I-N-E thine
And I will L-O-V-E love you all the T-I-M-E time
You are the B-E-S-T best of all the R-E-S-T rest
And I will L-O-V-E love you all the T-I-M-E time, time, time!

"Charlie on the MTA" [Steiner/Hawes]
[CHORUS:] Oh did he ever return, no he never returned
And his fate is still unlearned (poor Charlie)
He may ride forever 'neath the streets of Boston
He's the man who never returned

Oh let me tell you the story 'bout a man named Charlie
On this tragic and fateful day
He put ten cents in his pocket
Kissed his wife and family
Went to ride on the MTA

[CHORUS]

Charlie got on at the Scollay Square Station
Headed out for Jamaica Plains
When he got there the conductor shouted "One more nickel!"
Charlie couldn't get off of that train

[CHORUS]

All night long Charlie rides through the station
Shouting, "What will become of me?
How can I ever afford to see me sister in Chelsea
Or my cousin in Roxbury?"

[CHORUS]

Charlie's wife goes down to the Scollay Square Station
Every day at a quarter-past-two
And through the open window she hands Charlie a sandwich!
As the train comes rumbling through

[CHORUS]

Now ye citizens of Boston, don't you think it's a scandal
How the people have to pay and pay?

So in the coming election vote for George O'Reilly!
And get Charlie off the MTA!

[CHORUS, "Or else he'll…"]

"Chee-chee-o-pag-wa"
("Repeat after me" chant, sung at Junior Village campfires when campers have stepped over the benches or when they have not walked into the fire circle between the two totem poles.)
Chee-chee-o-pag-wa!
Say-o-pag-wa!
Go away rain!
Never come again!
Please!

"Clear Ahead, Clear Astern"
Clear ahead, clear astern, that's what really makes us burn
We're from Maijgren (stomp, stomp)

We can sail in any kind of weather
It just makes us sail a little better
We can't wait to leave the docks,
Don't forget the jib to box

Maijgren, that's us! *[repeat entire song ad infinitum]*

"The Cory Alma Mater"
On the shores of old Lake Keuka,
There's a spot most dear
Camp Cory we have named it
Come, let forth our cheer.

Cory, Cory, may we ever
Keep [or hold] thy name most high.
You have set a standard for us
May it never die!

"Cory Life"

(Sung at breakfast, only on Saturdays)
[CHORUS:]
O! I don't want no more of Cory Life,
Hey!
Gee, mom, I want to go
But they won't let me go
Gee, mom, I want to go ho-o-ome.

The bug juice at Camp Cory, they say it's mighty fine
It looks like muddy water and tastes like iodine!

[CHORUS]

The bus at Camp Cory, they say it's mighty fine
It went around the corner and left us all behind!

[CHORUS]

Et cetera:
chicken—It got up off the table and started marching time!
girls—They're either under seven or over ninety-nine!
nurse—I had a broken finger, she broke the other nine! (Or, "my friend he broke a finger…")
rolls—One rolled off the table and killed a friend of mine!
spaghetti—They flush it down the toilet and hang it on the line!
whales—We don't have any whales here, why do we sing this line?!
staff—La la la la la la la la la la la la la.

[CHORUS] Hey!

"The Deep Blue Sea" [The "Old Guy Song"]

Once I went a-swimmin'
Where there were no women
Down by the deep blue sea

Seeing no one there,
I took off my underwear
and hung it on a willow tree

I stepped into the water
Just like Pharaoh's daughter
Wading in the Nile

But someone saw me there
And took my underwear
And left me with a smile

"Desperado"
(Traditionally only sung at dinner on the last night of the summer.)
(Verses are "repeat after me," while everyone marches, and chorus is all together.)
There was a desperado from the wild and wooly West
Who wore a big sombrero and two guns across his chest
He rode out east just to give the West a rest
And everywhere he went he gave his war hoot!

[CHORUS:]
He was a big, tall man, he was a [jump] desperado!
From Cripple Creek, way out in Colorado
And he horsed around, just like a big tornado
And everywhere he went he gave his war hoot!

He went to Coney Island just to see the pretty sights
He saw the really pretty girls dressed in all their tights
He got so excited that he shot out all the lights (Ka-Bam!)
And everywhere he went he gave his war hoot!

[CHORUS]

He saw the big policeman just a-walkin' down his beat
He saw the desperado just a-walkin' down the street
He grabbed him by the shirt and then he grabbed him by the seat
And woosh! you couldn't hear his war hoot!

[CHORUS]
One more time!
[CHORUS] (extra loud)

"The Donut Song"
Well I went to Cincinnati,
And I walked around the block,
And I walked right into a donut shop,
And I picked up a donut,
And I wiped off the grease,
And I handed the man a 5-cent-piece.
Well he looked at the nickel,
And he looked at me,
And he said, "Kind sir, you can plainly see,
There's a hole in the nickel, and it goes right through!"
I said, "Ah, there's a hole in the donut, too!
Thanks for the donut, ta-ta!"

"Dunderback's Machine"
[CHORUS:]
Oh Dunderback, oh Dunderback how could you be so mean?
I told you you'd be sorry for inventing that machine
Now all the neighbors' cats and dogs will nevermore be seen
They'll all be ground to sausage meat in Dunderback's machine.

One day a boy came walking, came walking in the store
He bought a pound of sausage meat and laid it on the floor
The boy began to whistle; he whistled up a tune
And all the little sausages went dancing 'round the room.

[CHORUS]

One day the thing stopped working; the darn thing wouldn't go
So Dunderback he climbed inside to see what made it so
His wife she had a nightmare; came walkin' in her sleep
She gave the crank a heck of a yank and Dunderback was meat!

[CHORUS]

"Funky Chicken"
Let me see your funky chicken!
What did you say?
Let me see your funky chicken!
What did you say?

I said Oosh, ah-ah-ah-Oosh, ah-ah-ah-Oosh, ah-ah-ah-Oosh! (2x)
(This repeats ad infinitum, with different phrases inserted in the place of "funky chicken." Often, "Frankenstein," "Surfer Girl," "John Travolta," "Dracula," "cockroach," etc.)

"Hands on Myself"
Hands on myself! What's this right here?
This is my new-knocker, my momma, dear!
New-knocker, nick, nock, nock, new!
That's what I learned in my school, yahoo!
(Head—new knocker, ears—sound catchers, nose—horn blower, teeth—grub grinders, stomach—breadbasket, knees—leg elbows, feet—flip-floppers) *(Add a new body part each verse)*

"Head and Shoulders"
(This is a "repeat after me" song)
(clap on "one, two, three")

Head and shoulders baby, one, two, three
Head and shoulders baby, one, two, three
Head and shoulders, head and shoulders, head and shoulders baby, one, two, three
Knees and ankles baby, one, two, three (2x)
Knees and ankles, knees and ankles, knees and ankles baby, one, two, three
Pick an apple baby, one, two, three (2x)
Pick an apple, pick an apple, pick an apple baby, one, two, three
Scoop the cotton baby, one, two, three (2x)
Scoop the cotton, scoop the cotton, scoop the cotton baby, one, two, three
Round the world baby, one, two, three (2x)
Round the world, round the world, round the world baby, one, two, three
Head and shoulders, knees and ankles, pick an apple, scoop the cotton, round the world baby, one, two, three

Head and shoulders, knees and ankles, pick an apple, scoop the cotton, round the world baby, one, two, three
Head and shoulders, knees and ankles, pick an apple, scoop the cotton, round the world, Head and shoulders, knees and ankles, pick an apple, scoop the cotton, round the world, Head and shoulders, knees and ankles, pick an apple, scoop the cotton, round the world baby, one, two, three

"Hole in the Bottom of the Sea"
There's a hole, there's a hole, there's a hole in the bottom of the sea
There's a hole, there's a hole, there's a hole in the bottom of the sea
There's a hole! There's a hole. There's a hole in the bottom of the sea.
There's a log in the hole in the bottom of the sea
There's a log in the hole in the bottom of the sea
There's a hole! There's a hole. There's a hole in the bottom of the sea.
And so on, until…
There's a germ on the fly on the hair on the wart on the frog on the bump on the branch on the log in the hole in the bottom of the sea.
There's a germ on the fly on the hair on the wart on the frog on the bump on the branch on the log in the hole in the bottom of the sea.
There's a hole! There's a hole. There's a hole in the bottom of the sea.

"I Know You Rider" [traditional]
[CHORUS:] I know you, Rider, gonna miss me when I'm gone (2x)
Gonna miss your baby from rollin' in your arms
Laid down last night, lord I could not take my rest (2x)
My mind was wandering like the wild geese in the West

[CHORUS]

The sun will shine on my back door someday (2x)
March winds will blow all my troubles away

[CHORUS]

I wish I was a headlight on a northbound train (2x) (*second time shouting*)
I'd shine my light on the cool Colorado rain

[CHORUS]

"Jelly Fish"
[CHORUS:] A jelly fish, a jelly fish, a jelly fish-fish
VERSES: Arms up
Wrists together
Elbows together
Knees together
Toes together
Butt out
Head back
Tongue out
(Add one verse each time around, until eventually all verse lines are sung and performed before the final chorus. This is a "repeat after me" song, but the chorus is sung all together.)

"Junior Birdsmen"
Up in the air,
The Junior Birdsmen
Up in the air,
And upside-down
Up in the air,
The Junior Birdsmen
With their noses to the ground
When you hear the grand announcement
That their wings are made of tin,
Then you know the Junior Birdsmen
Have sent their box tops in.
What's it take?
5 box tops
4 box bottoms
3 wrappers
2 labels
and 1 thin dime!

"Little Red Wagon"
(This is a "repeat after me" song. Repeat three times, louder each time.)
You can't ride in my little red wagon!
The front seat's broken and the axle's draggin'!
Chugga, chugga, chugga-chugga-chigga!

second (or third) verse, same as the first, a whole lot louder and a whole lot worse!

"Maijgren Days"
Maijgren days are here again
So grab the helm and steer again
The skies above are clear again
Maijgren days are here again! *[repeat entire song ad infinitum]*

"The Mighty Duke of York"
(Sung 3 times, faster each time. Singers stand on "up," sit on "down" and crouch on "halfway.")
The mighty Duke of York,
He had ten thousand men.
He marched them up the hill,
And then he marched them down again.
And when you're up, you're up;
And when you're down, you're down.
And when you're only halfway up,
You're neither up nor down!

"The Moose" (or "Dah Moose")
(This is a "repeat after me" song.)
Dah moose, dah moose
Swimming in de watah
Not eating his suppah
Where did he go?
He went to sleep
He went to sleep

[Interlude:] Bring out the big [or little] moose ears!
(Repeat three times; once normal, once "big" and once "little," with a falsetto.)

"The Moose Song"
(This is a "repeat after me" song.)
There was a great big moose
He liked to drink a lot of juice
(2x)

[CHORUS:] Singing Oh-way-oh!
Way-oh-way-oh-way-oh-way-oh
Waaaaay-o, waaaaaay-o
Way-oh-way-oh-way-oh-way-oh

The moose's name was Fred
He liked to drink his juice in bed
(2x)

[CHORUS]

He drank his juice with care
But he spilt some on his hair
(2x)

[CHORUS]

Now he's a sticky moose
Cuz he's a moose covered in jooooooooooce!
(2x)

[CHORUS]

"The Morning Song"
Waaaay up in the sky
The little birds fly
While down in the nest
The little birds rest
With a wing on the left,
And a wing on the right,
The poor little birdies
Sleep all through the night
Shh…you'll WAKE the darn birds!
The bright sun comes up,
The dew falls away,
"Good morning, good morning,"
The little birds say.

Modern Songs and Stories of Camp Cory

"Old Lady Leary"
(Sung 3 times; the verse gets quieter and the "Fire! Fire! Fire!" gets louder each time.)
Late last night, while we were all in bed,
Old Lady Leary left a lantern in the shed
And when the cow kicked it over, she winked her eye and said,
"It'll be a hot time in the old town tonight
Fire! Fire! Fire!"

"Leary Old Lady"
(Revision to "Old Lady Leary")
Last night late, while bed we all were in
Leary Old Lady left a shed the lantern in
And when the kick cowed it over, she eyed her wink and said,
"It'll be a time hot, in the town old, tonight"
Ei-fer! Ei-fer! Eifer!

"O! The Joy of Nature!"
[CHORUS:]
O! The joy of nature
O! The great outdoors
Majestic eagle soaring
Mountain lion roars

Billy went a-hikin'
In the Great North Woods
Unpacked all his tent poles
And all of his canned goods

Boy it sure is great
To be out in the fresh air
But remember to be careful
And remember to beware

Billy wasn't careful
As he sat down in his chair
He forgot to keep a lookout
And was eaten by a bear

A History of Camp Cory

[CHORUS]

And now the tale of Sally
And her new fishin' pole
She gathered up her tackle
Drove to the fishin' hole

She caught a bunch of mackerel
She caught a big black bass
She loaded up her pickup
And hit the road at last

She didn't check the flatbed
For a stowaway back there
She pulled into her driveway
And was eaten by a bear

[CHORUS]

Now nature is exciting
But sometimes you need a rest
Hangin' out and watchin' stuff
Sometimes can be the best

Sean went to the movies
A safe place to relax
He bought a Coca-Cola
And a couple salty snacks

The movie sure was funny
The movie sure was great
Sean had such a good time
Then got eaten by a bear

[CHORUS]

Joey went to bird watch
In the woods of Delaware

He looked at all the wildlife
He loved the birds out there!

Darkness fell too quickly
It gave him quite a scare
His flashlight batteries ran out
He didn't have a spare

He started cooking dinner
The aroma filled the air
Delicious, juicy burgers
Tender, fresh and rare

And then you know what happened
I'm sure you are aware
He ate a tasty dinner
And went home without a care

[CHORUS]

"The Penguin Song"
Have you ever seen a penguin come to tea?
Take a look at me; a penguin you will see.
Penguins! Attention! Penguins! Begin [right arm, left arm, right leg, left leg, head]
[Final verse: Penguins! Attention! Penguins! Dismissed!]

"The Pirate Song"
When I was one I sucked my thumb, the day I went to sea.
I climbed aboard a pirate ship, the captain said to me,
"We're going this way, that way, forward, backwards, over the Irish Sea."
A juicy plum to fill my tum and that's the life for me! Arg!

(When I was two I tied my shoe,
…three I climbed a tree,
…four I opened the door,
…five I danced the jive,

…six I picked up sticks,
…seven I went to heaven,
…eight I shut the gate,
…nine I was feelin' fine!
…ten I did it again!)

"Princess Pat"
(This is a "repeat after me" song.)
The Princess Pat
Lived in a tree
She sailed across
The seven seas
She sailed across
The channel too
And she brought with her
A Rig-a-bam-boo

[CHORUS:] A Rig-a-bam-boo
Now what is that?
It's something made
By the Princess Pat
It's red and gold
And purple too
That's why it's called
A Rig-a-bam-boo

Now Captain Jack
Had a mighty fine crew
He sailed across
The channel too
But his ship sank
And yours will too
If you don't take a Rig-a-bam-boo

[CHORUS]

"Rattlin' Bog"

(Verses are "repeat after me"; chorus and refrain are all together.)
[CHORUS:]
Rare bog, rattlin' bog, way down in the valley-o. Rare bog, rattlin' bog, way down in the valley-o.

And in that bog
There was a tree
A rare tree
A rattlin' tree

[REFRAIN:]
And the tree was in the bog, the bog down in the valley-o.

[CHORUS]

And on that tree
There was a branch
A rare branch
A rattlin' branch

[refrain:]
And the branch was on the tree, and the tree was in the bog, the bog down in the valley-o.

(So on, with:
A rattlin' twig
A curious nest
A rattlin' egg
A rattlin' chicken! (bawk like a chicken on "chicken")
A rattlin' feather
A blood-suckin' tick
A rattlin' microorganism)

[VERSE:]
And on that microorganism
There was a whole 'nother world…

"The Rooster Song"
(Traditionally only sung at the Bluff.)
We had a tree, no fruit would it bear
We had a tree, no fruit would it bear
Until that rooster came into our yard
And caught that tree right off of its guard

It's bearing fruit now, just like it used to
Ever since that rooster came into our yard
It's bearing fruit now, just like it used to
Ever since that rooster came into our yard

We had a cow, no milk would she give (2x)
Until that rooster came into our yard
And caught that cow right off of its guard

She's giving milk now, just like she used to
Ever since that rooster came into our yard
(2x)

We had a hen, no eggs would she lay (2x)
Until that rooster came into our yard
And caught that hen right off of her guard

She's laying eggs now, just like she used to
Ever since that rooster came into our yard
(2x)

[Continue on with final verse, replacing "hen" with "rooster" and "eggs" with "hens."]

"Sailing, Sailing"
(Hum a new phrase each time, and sing the last line louder, like "Bingo.")
Sailing, sailing
On Keuka Lake
When days are windy and they're calm
On Keuka Lake

Main sheet, jib sheet, rudder, tiller too
Oh wouldn't it be nice to have something else to do?

"The Second-Story Window"
Jack and Jill went up the hill to fetch a pail of water,
Jack fell down and broke his crown and
Threw it out the window, the window, the second-story window.
Jack fell down and broke his crown and threw it out the window.
(And so on…)
—Humpty Dumpty
—Little Miss Muffet
—Little Jack Horner

"Stack and Scrape"
Stack and scrape,
Clean my plate,
Stack 'em high and stack 'em straight
Stack' em up—UP!
To the sky—SKY!
Stack 'em well and stack 'em SWELL!

"Swimming, Swimming"
(Hum a new phrase each time, and sing the last line louder, like "Bingo.")
Swimming swimming
In Keuka Lake
When days are hot, when days are cold
In Keuka Lake
Breaststroke, sidestroke, fancy diving too
Oh wouldn't it be nice to have something else to do?

"Taps"
Day is done
Gone the sun
From the lakes, from the hills, from the sky
All is well
Safely rest
God is nigh

"Tarzan"
(This is a "repeat after me" song.)
Tarzan
Swinging on a rubber band
Tarzan
Smacked into a frying pan
Ooo, that hurts
Now Tarzan has a tan
And I hope it doesn't peel
Like a banana

Jane
Flying in an aeroplane
Jane
Crashed into a traffic lane
Ooo, that hurts
Now Jane has a pain
And Tarzan has a tan
And I hope it doesn't peel
Like a banana
Like a banana!

Cheetah
Rockin' to the beat-a
Cheetah
Got eaten by an amoeba
Ooo, that hurts
Now Cheetah is velveeta
And Jane has a pain
And Tarzan has a tan
And I hope it doesn't peel
Like a banana
Like a banana!
Like a banana!!!

Modern Songs and Stories of Camp Cory

"Three Corners"

("My," "hat," "three" and "corners" each have hand motions, and one of these words is eliminated, in turn, each time you repeat the song—five times total)
My hat it has three corners
Three corners has my hat
And had it not three corners
It would not be my hat
Until...
...it has...
...has...
And had it not...
It would not be...

"Weenie Man"

(Sung three times, faster each time.)
I know a weenie man
He owns a weenie stand
He sells me everything from hot dogs on down (Boom, Boom, Boom)
Someday I'll be his wife
Eat weenies all my life
Hot dog! I love that weenie man!

"Woconda"

("Repeat after me" chant, sung before every campfire.)
Woconda!
Great god of fire and light!
Bless this wood!
To bring us warmth and light!
Please!
(Another improvised rendition includes chanting "Wo-mellow" before cooking s'mores.)

STORIES

The Man Who Loved to Fly

A man was dissatisfied with his life. He was depressed and felt that his life lacked adventure and excitement and that he had no interesting skills. All of the stresses he faced—work, family, bills—were just too much for him to handle. He began seeking help, and someone recommended that he take flying lessons. So the man went to the nearby airport, a small one, and enrolled in flying lessons. The instructor took him up in a small plane, and over the next few weeks the man began to become better and better at flying.

He loved it up there; he felt truly free those hundreds or thousands of feet above the ground. He began taking more and more lessons, and eventually he thought that he was able to fly planes on his own, so one day he did. He flew around in the sky for hours, marveling at how peaceful and serene everything seemed up there. All of the everyday problems he faced back on the ground seemed to melt away above the clouds. But eventually, he became low on fuel, so he decided that it was time to land. He began approaching the small airport, but every time he radioed the tower, no one responded. It was a very informal place, so the man decided that the airport staff must be out to dinner or something. He brought his plane in for a smooth landing and then drove it over into a hangar.

There was no one around: no other pilots, no airport staff, no passengers. The man looked into all of the offices, but they were empty. *Maybe they all took off early*, the man thought. He went out to the parking lot and began

driving home. But driving home was an eerie experience. There were no other cars on the road, and there were no people walking down any of the sidewalks. The man was disturbed, but he figured that there must have been a reasonable explanation for it. *Maybe the president got shot or something*, he thought. *Maybe everyone's inside watching the news.*

Finally he got home, and he saw his wife's car in the driveway. He went into the house, but no one was there. His wife, his children, they were all gone. He went next door to see if his neighbors could shed any light on what was happening, but they were gone, too. He couldn't understand it—there was no evidence that people had packed up or gone anywhere, they were just gone. In some houses, there was still food in the oven or on the stove. Certain electrical appliances were still turned on. Every number he called on his phone just rang and rang.

The man got into his car and drove around town for several hours but could still find no one. The next day, he went to the airport, gassed up his plane and decided to fly to one of the big cities in order to see if there was anyone there. There was no response when he radioed any of the nearby airports. He landed in a big city airport only to find that that city was deserted, too. The man was very afraid. *What if I am the last man on Earth?*

He went to the airport and got one of the big jets. He had never flown one of these before, but he thought he was capable. He flew all over the country, checking every city, but everywhere it was the same. There were simply no people. At one of the cities, he stopped by a pharmacy and took sleeping pills. Then the man drove out into the countryside and hiked into the woods. He planned on taking the pills in order to commit suicide—*After all, there's nothing really left to live for. There is no one else out there.* The man sat on a rock, ready to take the pills, and looked around at the peaceful wilderness. Then he decided, *No. Not yet.* He decided not to give up. He went back, got a giant jumbo jet and flew across the ocean. He toured Europe, checking all of the major cities and some minor villages. It was beautiful, but still, there were no people.

Finally, after years had passed, the man went into a local hospital. This time, he thought, he was going to take the sleeping pills and end it all. It would be peaceful, he knew. He had purposefully gotten pills that would simply make him go to sleep as painlessly as possible. He would simply stop breathing.

So he lay on one of the comfortable hospital beds, and then he swallowed the pills. He thought about his life and about his travels around the world these past years. *At least*, he thought, *I might find out what happened to everyone.* He lay there breathing, and his breathing became more and more labored. The time was approaching. He felt himself drifting away, and he became weaker and weaker. He took a breath and let it out. Then another, and let it out. Finally, he took a long breath, and he knew, he could feel it, that this would be his last. He finished breathing in, just about to breathe out his last breath, when at the other end of the room he heard a phone ring.

The Monk Story

There was a man who was very dissatisfied with his life. He hated his job and was just in general not happy. As he was driving home from work one day, he got a flat tire. He was not near a phone and had no cell phone, so he began walking toward the nearest light that he saw. He came to the door of a great building, and he saw that it was a monastery. He knocked on the door, and one of the monks answered. The monk said that they had no phone, but one of the other monks could see to it that the man's car would be fixed by morning. In the meantime, the man was welcome to stay the night in the monastery.

He ate dinner with the monks, and he saw that they seemed to enjoy their lives. He went to bed in a comfortable room and found that he went to sleep easily. But he woke up in the middle of the night because he heard a noise off in the distance. "Ka-thump, ka-thump, ka-thump," it went. The man was curious, but he was also tired, and he was a guest, so he just shut it out of his mind and went back to sleep.

The next morning he was having breakfast with the monks, and he told the Head Monk that he'd heard a noise in the middle of the night. He asked what the noise had been. The Head Monk said, "I cannot tell you, for you are not a monk." The man nodded, went out to his car and saw that the tire had been replaced. He went back to his unsatisfying job and his unsatisfying life.

Months later, the man got a flat tire in front of the same monastery. They agreed to let him stay the night again, and again he heard the noise in the middle of the night: "Ka-thump, ka-thump, ka-thump." This time he left his room in order to see if he could find where the noise was coming from. He got out into the hallway and realized that the noise was louder and that

it was coming from somewhere down in the basement of the monastery. He was walking toward where the sound was coming from, "Ka-thump, ka-thump, ka-thump," when he ran into the Head Monk. The Head Monk asked what he was doing, and the man admitted that he'd been searching for the source of the noise. The Head Monk said, "What that noise is, you cannot know, for you are not a monk."

The man left the next morning but found his life to be just as unsatisfying. Finally, he decided that he would become a monk. He went to the monastery and told them that he wanted to join. So he trained, read books of lore and learned agriculture, prayer and theology. All the time, he heard the noise at night, "Ka-thump, ka-thump, ka-thump," and all the time the Head Monk said that he could not know what the noise was yet, "for you are not a monk." The man studied for hours and days in the library, took a vow of silence for a month and passed all of the other tasks that were appointed him.

Finally, he took his vows. He was a monk. It was nighttime, and he was in his room. The Head Monk came to get him in the middle of the night and took him into the hallway. The man could hear the noise, "Ka-thump, ka-thump, ka-thump." They walked down a spiral staircase and came to a basement. Here the noise was louder. "Ka-thump! Ka-thump! Ka-thump!" They took another staircase down into a subbasement and walked down an old storage corridor. The noise was even louder. "Ka-THUMP! Ka-THUMP! Ka-THUMP!" The man could tell that the noise was coming from behind a giant door in front of him.

They got to the door, and the noise was coming from right behind it: "KA-THUMP!!! KA-THUMP!!! KA-THUMP!!!" The Head Monk opened the door. But what they saw on the other side, I cannot tell you, for you are not a monk.

Omri and His Hardships

There was a boy in Africa named Omri. He was very poor, just like everyone else in his small village, and he suffered many hardships. One day, some tourists came through the village in a Jeep, and they were dressed in very nice clothes and had very nice things. Omri asked them where they came from, and they said, "America!" He asked them about America, and for almost an hour they talked to him about it. It seemed like America was a great place, where there was nothing bad. Finally, Omri asked where America was, and they pointed westward, saying that it was very far away, over a great body of water.

Then the tourists left, but Omri was determined to get to America. So one day he decided to leave the village. He traveled for days and days through the desert and suffered many hardships, but he didn't give up. He came to a lake in front of him, and though he had never swam before, he decided that he had faced so many hardships already that learning to swim and swimming across the lake was just one more hardship. So Omri swam across the lake.

Then he traveled through the jungle and faced many hardships. Finally, he came to a beach, and he saw water in front of him, but there was so much water that he couldn't see the end. He had faced so many hardships already that Omri decided that he couldn't turn back now. So he started swimming. He swam and swam and swam and swam, and still he could not see the land at the end of the water. Finally, Omri realized that he would run out of energy soon and drown. Just as he was about to let go, he saw a giant wooden ship approaching. He waved down the ship, and it picked him up.

But it was a pirate ship, and Omri was forced to work as a slave in the galley. He suffered many hardships and spent a long time on the ship, until finally, one day, he saw land, and he knew that this was the other side of the ocean. He ran out of the galley and tried to escape from the ship, but the pirates chased him. He climbed up the mast so that he could jump into the water and swim to shore. But just as he jumped, the boat turned quickly, and Omri SMACKED into the deck.

But that's OK, because he was used to hard ships.

The Philadelphia Experiment
World War II had begun. The German navy's underwater U-boats were sinking American ships faster than they could be built. The most dangerous weapons for an American boat to face were magnetic torpedoes and magnetic mines. The Americans needed a solution in order to regain naval superiority, or to at least level the playing field.

Enter Albert Einstein. He had been working on a pet project of his, known as the Unified Field Theory. Essentially, Einstein was seeking to prove that magnetic, gravitational and electric forces were all interrelated. We now know that there is some relationship between these three forces, but the Unified Field Theory has yet to be proven. In any case, Einstein had the idea of demagnetizing the American ships—"degaussing" is another term. This

was the only practical way of avoiding the magnetic mines and torpedoes (porcelain ships were another option but were not economically feasible and wouldn't have held up to the strains and stresses of ocean voyages).

The USS *Eldridge* was commissioned in the summer of 1943. Almost immediately, it became the subject of a top-secret experiment. The navy, following Einstein's instructions, wrapped large-gauge copper wire all around the ship, with the goal of demagnetizing the ship once electric current was run through the wires. At the naval shipyards in Philadelphia, all was ready, and the *Eldridge*'s sister ship was nearby, with all sorts of scientific equipment at the ready, to measure the effects of the experiment.

The switch was thrown, but at first nothing happened. Then, a green haze seemed to envelop the *Eldridge*, and a persistent buzzing sound filled the air. This was interesting but was not the goal of the experiment. A few more moments passed, and then the *Eldridge* became successfully degaussed! The monitoring equipment on the sister ship showed that the experiment had worked. But then, something unexpected happened. After a few more moments passed, the *Eldridge* became literally invisible. No one on shore could see it, and neither could the sister ship visibly see the *Eldridge*. However, the observers knew that the *Eldridge* was still there, because they could see its wake in the water, they could see displacement of the water where its hull went underneath and they could still contact the ship over the radio.

After a few more moments, the *Eldridge* actually vanished. It was now legitimately gone—no wake, no displacement in the water and it could not be contacted by radio. Moments later, the *Eldridge* appeared at the naval yards in Norfolk, Virginia. The officers and men in Norfolk had just enough time to be surprised before the *Eldridge* disappeared once more. Moments later, it reappeared with its crew back in Philadelphia, although not all at once. The boat appeared first and cruised forward for a few seconds before the crew members reappeared. This resulted in some of the crew members being stuck within bulkheads, crew members with hands stuck in doors and even one crew member who had a railing running straight through his body. One crew member, too, was in the water beside the ship.

The men were all taken off the boat and debriefed. The story of the experiment was hushed up, although there were side effects that continued to plague the men for years to come. For one thing, at random moments the men who had been on the *Eldridge* at the time of the experiment would

spontaneously erupt into flame. The flame, however, would not harm the men at all. A second side effect was "phase shifting," when someone would suddenly freeze, not responsive to anything around him, as if he had been "paused." He would come to moments later as if nothing had happened. The third side effect was that the *Eldridge* crew members had a tendency to randomly disappear. This happened at least once at a bar in Boston. The two former *Eldridge* men were involved in a fight with one another, a crowd grew around them and then they both disappeared before the eyes of the onlookers. As the years went by, more and more of the *Eldridge* crew became interred in mental institutions.

One crew member, however, had given a detailed account of the experiment to his navy superiors right after the experiment occurred. His name was Carl Allen, and he was a young sailor who had lied about his age in order to sign up for the navy—he was too young at the time. He was the crew member who had jumped into the water during the experiment. In any case, he told his superiors that after the *Eldridge* had disappeared, it had teleported to Norfolk, Virginia. He said that they had then traveled in time to the year 1983, where Allen claims he saw his future self. They had only been in 1983 for ten seconds or so, though, before they shifted back to Philadelphia in 1943. Allen's story was discounted, and he seems to have disappeared off the grid for some time after this. He would send random, cryptic letters to the Pentagon, though, trying to explain the science behind time travel, teleportation and even alien technology and alien life. The letters were strange, often written in different colors, with randomly capitalized letters and inexplicable underlining of random words. It may have been a code, but no one understood what it meant.

Then, in the 1950s, a man named Morris K. Jessup wrote a book called *The Case for the UFO*. In the book, he alleged that the military had known about alien life for years and had been experimenting with alien technology. Carl Allen reemerged, this time calling himself Carlos Allendale, sending an annotated copy of the book to the Pentagon. He reaffirmed some parts of the book, corrected others and essentially tried to reinforce Jessup's claims with his own theories and observations. Someone at the Pentagon made ten copies of the annotated version and distributed it to various officials. However, the navy continued to publicly deny any knowledge of the Philadelphia Experiment and publicly denied all of the allegations in Jessup's book.

In the early 1980s Carlos Allendale emerged again, although this time he was somehow working for the navy. He had convinced them to re-conduct the Philadelphia Experiment; in order to do so, they had set up two giant radio towers in the water outside of Norfolk, Virginia, with large-gauge copper wire strung between the two towers. The switch was flipped once again, and again, nothing happened—at first. Then, a green haze began to appear between the two towers, and moments later, the USS *Eldridge* appeared! It was apparent that this was the *Eldridge* from the experiment in 1943 and it had time traveled to them in 1983. Carlos Allendale saw his past self, Carl Allen, on the ship and smiled just before the *Eldridge* vanished once again, back to 1943.

The navy continues to deny that the Philadelphia Experiment ever happened, although there are aspects of the story that might be explained through ordinary scientific method. First, the "teleportation" to Norfolk may have been the result of a "big fish" story. The *Eldridge* was a newer, faster boat that could stay closer to shore and could use inland water channels, so perhaps it arrived in record time, and with each retelling of the trip, the voyage became shorter and shorter until it happened "instantly." Second, the green haze could have been St. Elmo's fire, an atmospheric phenomenon that occurs when electric fields are ionized. Third, the *Eldridge* disappearing from view can be explained as having been a mirage—similar to when, on a hot day, the road ahead might appear to be underwater. The true story, of course, remains unknown, but people who are interested should do their own research—they might be surprised at what they find!

Purple Passion

A boy and his family moved to a new town. The boy was nervous for his first day of school as he walked to the bus stop in the morning. On the way, he saw two older children talking and laughing among themselves. They stopped and talked to the New Boy and asked him who he was. "I'm new in town," said the boy. One of the older children said, "There's one thing you need to know about living here: never, ever say the words 'purple passion.'" The New Boy headed off to school, confused about what the phrase meant.

As he was sitting in class, the New Boy was still thinking about what "purple passion" could mean. The teacher introduced the New Boy to the rest of the class and asked if the New Boy had anything he wanted to say.

The New Boy paused and then asked the teacher, "I was just wondering…
what is purple passion?" The teacher stopped for a moment: "What did
you just say?" The New Boy repeated, "I just wanted to know what purple
passion was." The teacher turned red and became very angry. "Get out of
my class!" He shouted. "Go to the principal's office!"

The New Boy went to the principal's office and was very confused. The
principal seemed a very nice man and calmly told the New Boy to sit down.
He smiled and asked the New Boy why he was already sent to the office on
his first day of school. The New Boy said, "I don't really know. I just asked
my teacher what 'purple passion' meant." The principal frowned. "What
did you just say?" The New Boy said, "I just don't know what purple passion
means." The principal, hiding his shock, said to the boy, "You need to go
home right now. Go. Now!"

The New Boy walked home, sad and confused about what had happened.
He was waiting in the kitchen when his mother came back from the store.
She asked him why he was home from school, and he explained to her, "I
just asked what purple passion meant!" His mother shrieked and sent the
New Boy to his room: "Go and wait upstairs for your father to come home!"
The New Boy waited in his room, confused and sad as ever. Hours passed,
and finally he heard the sound of his father's car pulling into the driveway.
The New Boy was scared about what his father might do, but he was also
hopeful that he could still, somehow, sort this whole mess out. "Son!" The
father called. "Son, would you please come down here?"

So the New Boy went downstairs, and the father prompted, "Your mother
says you were sent home from school today, and that you have something to
tell me…" The New Boy was wary at first and then said, "I just asked my
teacher, and the principal, and mom, what 'purple passion' meant." The
father lowered his head. "Son, you need to go, now. Get out of the house."
"But—" "Just go!" the father shouted, and the boy ran out onto the sidewalk.

He walked down the street, wondering what had just happened to him,
when he saw the older boys from earlier in the day. They were walking on
the other side of the road, talking to one another. The New Boy decided to
run over there and ask what "purple passion meant." He rushed out into the
middle of the street and was hit by a truck.

The moral of the story is to always look both ways before crossing the
street.

Purple Passion Bear

(How the narrator comes to the house varies with the storyteller. This is my version.)

I was driving aimlessly on the rural roads of Livingston County. The day was passing quickly, and I thought I knew of a shortcut that would take me down to Conesus Lake, from where I knew a faster road back to the Village of Geneseo. I passed an old cemetery and ahead of me I saw a sign: "Seasonal Use Highway, Open April 1st–November 1st." This being the middle of March, the road was obviously not meant for use. But I thought that I could still drive down the road, so I went ahead.

My car became immediately stuck in the mud. No matter how hard I tried to go forward or back, or how hard I twisted the tires back and forth, the car simply wouldn't budge. I was far enough out where I got no cell phone reception, so I left my car there and walked down the hill in order to try to find someplace where I could call a tow truck. After a while, it was beginning to get dark, and I saw an old house tucked into the trees, beside a field. I went to the house, knocked on the door and a man answered. The man, Greg, said that he could get me a tow truck but I would have to wait until morning before the repair shop would send one out. The house, it turns out, was a bed-and-breakfast, and I was welcome to stay in the very last room he had left. "But," Greg said, "it's very important that you do not move the bed." I said OK and went into the room.

I lay there for a little while, about to drift off to sleep, when I became curious about moving the bed. Why was I not allowed to move it? What was under it? So I got up out of bed, looked it over and dragged it to the far side of the room. Beneath the bed was an old, red, Persian rug. I pushed the bed back into place and lay down, but just then the phone in my room rang. It was Greg, calling from down at the front desk. "You moved the bed, didn't you?" he asked. I admitted, "Yeah, I did." He said, "OK, that's OK, just whatever you do, don't lift up the carpet." I assured him that I wouldn't and climbed back into bed. After a few minutes, though, I became curious about what was under the carpet.

So I moved the bed again and lifted up the carpet. Underneath was an old wooden hatch with a metal ring handle in the middle. The phone rang in my room; it was Greg. "You looked under the carpet, didn't you?" I sheepishly admitted that I had, and he said, "OK, that's OK, just don't go down into the hatch." I assured him that I wouldn't do it, but immediately after hanging up the phone I opened the hatch up and looked down. I could see an old,

stone spiral staircase leading downward, and at the end of it, a faint light was showing. I closed the hatch, put the rug back, moved the bed back, got in it and pulled up the covers.

Greg called again and asked if I had opened the hatch, and I admitted it. He asked me politely (he was very polite) not to go down the staircase, and I assured him that I was too tired to do anything more than go to sleep. I hung up. But there was no way I was going to sleep now! I moved the bed, moved the rug, opened the hatch and down the stairs I went. The light at the end of the staircase, it turned out, was an old torch. And I could see that there was a long, long stone hallway that led off into the darkness. I took the torch and started walking until I came to a gigantic set of wooden doors. The doors had to be twenty or thirty feet high and seemed strong as a castle's doors. I went back down the hallway, put the torch back, went up the stairs, closed the hatch, moved the rug, moved the bed and lay there in bed, thinking.

What was on the other side of those doors? What could Greg have down there below his bed-and-breakfast near Geneseo? Could I go the rest of my life regretting not having tried to open them? I moved the bed, lifted the rug, opened the hatch, went down the stairs, grabbed the torch, went down the hallway and pushed open the doors. They gave way, and I could see that in front of me was a gigantic room, like the inside of an empty warehouse. Well, almost empty. On the far side of the room, there was a giant cage with a white sheet thrown on top of it. I couldn't tell, but it looked like there was something breathing under there.

OK! I went back through the doors, closed them, went down the hallway, put the torch back, went up the stairs, closed the hatch, moved the rug, moved the bed and lay there. I was scared at first, but then my curiosity got the better of me. After all, I *had* to know what was in that cage! I moved the bed, moved the rug, went down the stairs, grabbed the torch, went down the hallway, opened the doors, went across the room and looked under the sheet. The first thing I saw was a patch of bright purple fur. I lifted the sheet a little more and I saw that this creature, sleeping in this cage, was none other than a Purple Passion Bear!

Purple Passion Bears are very rare. There are only about six of them left in the entire world, and somehow Greg had got one below his house. A ten-foot-tall Purple Passion Bear! I turned to walk away but then paused. Purple Passion Bears are known to have extraordinarily soft fur. I couldn't let myself

leave without at least touching it, could I? So I, very slowly, reached out and touched the fur, ever so gently.

The bear instantly woke up. "Roar!" The giant fifteen-foot-tall bear tried to reach for me through the bars! I ran across the room, closed the doors, ran down the hallway, put back the torch, ran up the stairs, closed the hatch, threw the rug over the hatch, moved the bed back and climbed under my covers for extra protection.

From down below I could hear the Purple Passion Bear roaring and shaking in its cage. "Roar! Roar! Crash!" I heard the cage break. Boom! Boom! Boom! Boom! The bear walked across the room. Slam! Slam! Slam! I could hear him banging against the giant double doors. Crash! He broke through those, too! Boom! Boom! Boom! Boom! Boom! I heard him below me, walking down the long corridor. BOOM! BOOM! BOOM! He came up the stairs!

...Then there was a moment of silence. Maybe I was safe! Then, CRASH! He came bursting through the hatch, this twenty-foot-tall beast! The bed, with me in it, was thrown to the other side of the room. I lay there, cowering under the covers, while this thirty-foot-tall bear stormed across the room toward me, BOOM!!! BOOM!!! BOOM!!! It looked at me for a moment, and then it reached out a giant Purple Passion Bear paw, tapped me on the shoulder and said, "Tag, you're it."

The Story of Pink

There once was a very rich man. He was so rich that he could have anything he wanted—he need only think of it and pay for it, and it would be his. He had gotten to the point where he had bought everything that he would ever want to buy, so he began to learn things. He spent years learning all sorts of skills: trades, sports, art. Finally, he became bored with life. He realized that there was nothing left to interest him, and he became depressed.

One morning, as he was depressedly reading the newspaper, he saw an advertisement in the classified ads: "Learn how to make pink." Below this line there was a phone number, and that was all. There was no explanation. The Rich Man was intrigued—did the advertisement just mean how to make the color pink, or was there something else that he hadn't heard of before? He called the number, and the phone rang dozens of times before someone answered. It was an old man's voice that came through the line. The Rich Man said, "I'm calling about learning how

to make pink?" And the old man said, "Yuh, yuh, yuh." And the Rich Man said, "Does this mean the color pink, or…?" And the Old Man said, "Nope, not the color pink. The only way to know what pink is, is to make it." The Rich Man was interested, and the Old Man gave him an address, way out in the wilderness.

The Rich Man traveled to the Old Man's address. He found that the Old Man was living in a shack down by a lonely pond, far from the sound of the cities. The Rich Man entered the shack and told the Old Man that he was ready to learn how to make pink. The Old Man said, "You're not ready yet. First you need to do some things for me." The first thing that the Old Man asked for was a bowl of the old tan M&Ms. When they made the new blue M&Ms, they got rid of the color tan. So the Rich Man, though confused, called up some people he knew, lobbied the candy company, had one of his companies build a factory dedicated to making the tan M&Ms and filled a bowl especially for the Old Man. This took over a year. The Old Man ate the M&Ms and said, "Mmm. Mmm." The Rich Man asked, "Now can I make pink?" And the Old Man said, "Nope. Not yet. Next I need a rowboat whose oars won't make a sound."

So the Rich Man got his company right on it. They spent years developing the technology for silent rowboat oars. Finally, when it was done, the Rich Man reported back to the Old Man at his shack. "Now can I make pink?" the Rich Man asked. "Nope, not yet," the Old Man said. "Next I need a gun that can shoot a bullet without making any noise; any noise at all."

So the Rich Man got his people right on it. They spent years developing the technology for this silent gun. Finally, the Rich Man reported back to the Old Man. The Rich Man asked, "Now can I make pink?" And the Old Man said, "Not now…tomorrow morning. Stay here tonight, and I'll wake you up tomorrow."

So the Rich Man went to sleep in the shack. The Old Man woke him up in the very early morning, before the sun had risen. They walked quietly down to the rowboat, which was waiting at the shore of the pond. The Old Man crept silently in, but the Rich Man plodded into the boat, causing a splash and upsetting some ducks that were nearby. The Old Man stopped, "Not today. Let's try again tomorrow."

So the Rich Man spent another night at the shack. The next morning they went down to the boat again, before dawn, and the Rich Man made sure he was extra careful and quiet when he got into the rowboat. They

paddled out to the middle of the pond with the silent oars, not making a sound. And when they got there, the Old Man pulled out the gun. The Rich Man thought, "Why? Why did he make me do all of this work just so that he could take me here and kill me?" But then the Old Man aimed the gun straight up into the air and pulled the trigger. A bullet silently flew up.

There was nothing but silence for a few moments. Just as the Rich Man was about to ask what they were waiting for, the bullet came back down into the water and went "pink."

NOTES ON MODERN SONGS AND STORIES

SONGS

"Announcements Song"
This is also a Cub Scout cheer. Some camps add on more and more until this song is an epic. For example, they will sing "Words of wisdom, words of wisdom, we don't need" to the tune of "Frère Jacque;" "Make the announcements short and sweet" to the tune of "London Bridge;" "What do you do with a program director? / Hit him in the face with a chocolate cream pie!;" and, finally, "Speak Freak/Talk Jock/Rap Sap/So What's the point?"

In some years, the line "Message in a Bottle," from the song by The Police, has been sung when someone has spoken the word "messages."

"The Bear Song"
This is one of the most well-known camp songs in the country. Variations arise in the middle of the song, when the narrator responds to the bear's suggestion to run, and at the end of the song, when the story is left open-ended, or the narrator may make the bear into a rug on his bathroom (or kitchen) floor. Some people elect to sing a final verse consisting only of "The end, the end."

Modern Songs and Stories of Camp Cory

"Brian Grogan's Goat"
Originally titled "The Goat," this song has been present at Camp Cory for several decades, if not since the time of the camp's Keuka Lake inception. The song exists at many other camps, usually as "Bill Grogan's Goat." This was its title at Camp Cory until Brian Grogan began attending. Grogan, who was a camper in 1971 and apparently a staff member from 1972 to 1984 (including sailing master, 1977–78), found the song revised one summer to include his name. The song has evolved—like many Cory tunes—from a more melodic style of singing to an enthusiastic yell.

"The Cannibal King"
This song was already known throughout the country as a lullaby in the 1950s, albeit with some minor lyrical and structural variations. In particular, the "ah-rump" or "ba-roomp" chorus is repeated, substituting the kisses with "ma-ma," "gran-ma" and eventually a silent pause. In some versions, the title character is a "Zulu King" (the Zulus are from around South Africa), and in others he is king of the Hottentots (also called the Khoikhoi, and also located in southern Africa).

It could be based on an older song, "King of the Cannibal Islands," the melody for which has been around since at least the 1890s. In fact, it is possible that the song was originally written before 1830, when it was entered into the British library catalogue by an A.W. Humphreys. The lyrics at this time were very violent, and the king had "only" one hundred wives. "Every week he was a dad, Upon my word it was too bad, For his dears soon drove him mad." The chorus went:
Hokee pokee wonkee fum,
Puttee po pee kaihula cum,
Tongaree, wongaree, ching ring wum,
The King of the Cannibal Islands.

"Charlie on the MTA"
This is based on the Kingston Trio version of the song, though some of the lyrics have been changed and the fashion of singing is much more energetic. Several persons are often directed to skip around the fire circle while the song is sung. Like the Kingston Trio version, the Maijgren Village version omits a verse from the song (the Trio replaced this verse with a banjo solo):
As his train rolled on underneath Greater Boston
Charlie looked around and sighed:

"Well, I'm sore and disgusted and I'm absolutely busted;
I guess this is my last long ride."

There might be another verse, too, that goes:
"I can't help," said the conductor, "I'm just working for a living,
But I sure agree with you.
For the nickels and the dimes you'll be spending in Boston
You'd be better off in Timbuktu."

George O'Reilly is a modified version of the name Walter O'Brien, who ran for mayor of Boston on the Progressive Party ticket. Jacqueline Steiner and Bess Lomax Hawes adapted the song in 1948 from the 1830 song "The Ship that Never Returned." Steiner and Hawes made "Charlie" one song among seven that emphasized different parts of O'Brien's platform. These songs were played repeatedly on a truck that drove around the city, eventually drawing a fine for disturbing the peace. O'Brien went on to lose the election and in 1957 moved back to Maine, where he became a school librarian and bookstore owner, died in 1998 and was forever known in Boston as a peace-disturbing radical. The song changed from Walter to George during the McCarthy era, when the Progressive Party was seen as synonymous with Communism.

"Charlie" is so well known in Boston that the MBTA's "Easy Way" card-based fare collection system, which replaced the traditional token system in 2006, has been officially nicknamed the "Charlie Card." Apparently there are people who actually analyze the lyrics to determine on which line Charlie was riding: it was the Green Line.

Bear Family Records issued an album of protest music that contains a relatively contemporary version of the song.

"Clear Ahead, Clear Astern"
Set to the tune of "I'm Your Mailman," a bawdy, entendre-filled musical number about a postal worker.

"Cory Life"
The song can be traced back to an old army cadence and is also sung at scout camps nationwide. The "whales" verse was added in 2005 as a way of jokingly appeasing the claims by some that a verse was being left out

somewhere. Some of the verses sung regarding the army, including a contradictory closing verse, are as follows:
The salary they pay us, they say is mighty fine.
They pay a hundred dollars, and take back ninety-nine.

They say that in the air force the girls are mighty fine
They look like Phyllis Diller, and walk like Frankenstein.

But Momma, dear, the truth is, we know it's mighty fine,
We love it all, no kidding, we think it is sublime,
We still want some more of army life,
No, Mom, we're not coming home!

At Girl Scout Camp:
The toilets that they have here are the best that they can get
Last night my tent mate had to go, they haven't found her yet.

The verse about the staff is consistently sung as a very loud "La-la-la-la-la-la!" Previously, it was a murmur. At some camps, the counselors "march around like Hitler, and look like Frankenstein."

"Desperado"
A Camp Seagull song. "Hoochie coochie" girls was changed to a more appropriate phrase. The tradition of only singing this song once, at the last dinner of the summer, began in 2005.

"The Donut Song"
Sometimes called "The Cincinnati Donut Song." This song is to the tune of "Turkey in the Straw" and has several variants depending on region and organization. Whereas in the Cory version the narrator goes to Cincinnati, other versions take place in Toledo or "around the corner."

"Turkey in the Straw" dates back to the early nineteenth century, when it was a popular fiddle song. Beginning in the 1820s and 1830s, it was a popular tune to play to back up blackface minstrelsy performances. It was first published under its official name in the year 1861, but there existed countless different versions with different lyrics. The music appeared in the popular Mickey Mouse cartoon *Steamboat Willie*, which premiered in

1928. Although this was not the first appearance of the cartoon mouse, it was the cartoon that made him popular. Ever since that time, the music to "Turkey in the Straw" has appeared in many different Disney and Looney Toons shorts.

"Dunderback's Machine"
Brought back to Camp Cory in the late 1990s by Carl "Chris" Reynolds and Dave Reynolds. This song has been present at camp for many decades, possibly since around the time of its inception. Chris Reynolds, Sailing Master in 1997 and 1999, revived the song, and it was sung in Maijgren thereafter. A narrative version of this song is found in Alvin Schwartz's *More Scary Stories to Tell in the Dark* (HarperTrophy, 1984).

The song is traditionally sung to the tune of "Son of a Gambolier," which in turn inspired the tune for "I'm a Ramblin' Wreck from Georgia Tech," that institution's marching band theme song.

In one of the older Camp Cory culminaries is a previously lost first verse:
In a store at Palamore there lived a mean old man
His name was Mr. Dunderbeck and he could surely can
The place was filled with cats and dogs, and ring-tailed rats a few
So Dunderbeck invented a machine to grind them all to stew.

"Head and Shoulders"
Brought to Camp Cory by two Australian counselors, Dale Pendlebury and Kath Lyons, in 2001.

"Junior Birdsmen"
Sung at breakfast. This song has quite a history. It is definitely sung in Boy Scout camps throughout the country, and U.S. Air Force cadets supposedly started learning it during training starting around the time of World War II. There are many different variations to the lyrics of this tune, but almost all of them include instructions on how to achieve the hand gesture for the traditional Birdman goggles.

Decades ago, the song ended with an added line: "Don't be a glutton! Get your Captain Marvel button!" Near the end of Tim Burton's *Batman* (1989), Jack Nicholson, as the Joker, quotes the song while in his helicopter.

Modern Songs and Stories of Camp Cory

"Little Red Wagon"

Another popular song at camps all over the country, this tune is also sometimes sung as a military cadence. Cadences are chants that soldiers "sing" in order to keep the rhythm of their marching or running. Sailors likewise developed the sea shanty. In any case, drill instructors make up their own microcosm in the tradition of folk singing, as songs are developed and passed down to recruits. Indeed, new songs are created all the time, as there are currently prominent cadences that feature Osama bin Laden as a main character.

"Jody call" is a name that refers to a more common type of military cadence. In this case, "Jody" is either a man or a woman (i.e., Joe D., Joady or Joe de ____, the latter being an obvious derivation of the early African American chants from which American military cadences sprouted. The song would be about "Joe de Farmer" or "Joe de Banker," and so forth). The marchers sing about how Jody enjoys a luxurious lifestyle while the soldiers themselves are subject to a Spartan lifestyle; indeed, "Jody" often steals jobs, wives, cars or houses from the absent soldiers.

"Maijgren Days"

Based on "Happy Days Are Here Again," a song from 1929.

"The Morning Song"

Sung at breakfast. This song is also present at other camps, sometimes with an added verse in which the birds are killed by the owner of the land on which their nest is located. "A hunter comes out/a gun in his hand/Bam bam! Bam bam!/'No birds on my land.'"

"Old Lady Leary"

This song refers, obviously, to the Great Chicago Fire of October 8–10, 1871. "Old Lady Leary" is Catherine "Kate" O'Leary, whose cow purportedly started the fire by kicking over a lantern. Recently, scholars have begun to think that O'Leary, an immigrant who was living on welfare, was merely a convenient scapegoat. Some theorize that Daniel "Pegleg" Sullivan started the fire while gambling with Catherine O'Leary's son in the barn, while others allege that the true cause of the fire may never be known.

Catherine O'Leary was an Irish immigrant, born circa 1827, making her only about forty-four at the time of the fire, hardly an old lady. The fire started on the evening of October 7 at 137 DeKoven Street and ended

up causing damage equal to one-third of the city's valuation. It also left a burn path about four miles long and three-quarters of a mile wide, ninety thousand homeless and two to three hundred dead.

"O! The Joy of Nature!"

Written and originally performed by then–Program Directors Bo Shoemaker and Aaron Wiener in 2008. The song is performed in the key of G.

"Princess Pat"

There is another verse at some camps in which Princess Pat and Captain Jack marry, eventually having children:

Princess Pat and Captain Jack
They fell in love and that was that!
But that's not all that they could do
They had ten kids on a rigabamboo.

Princess Patricia of Cannaught was the daughter of a governor general of Canada (1911–14) and a granddaughter of Queen Victoria and Prince Albert. The song rightfully belongs to the Princess Patricia's Canadian Light Infantry, a privately initiated military unit created to bolster Canada's pitifully weak forces at the beginning of World War I. The "rigabamboo" (actually called the "Ric-A-Dam-Doo") refers to the regimental colors, which are actually red, gold and royal blue. There exists a version of the song mentioning the infantry regiment itself, and the dozen or so verses mention particular aspects of the unit that make it laughable. The actual regimental song contains verses explaining the different aspects about the regiment that make it so great. For example:

The Bombers of the Princess Pat's
Are scared of naught, excepting rats,
They're full of pep and dynamite too,
They'd never lose the Ric-A-Dam-Doo,
Dam-Doo, Dam-Doo.

"Rattlin' Bog"

This song, as well as "Desperado" and some others, was brought to camp in 2002 by Rick Coyle. He had worked at Camp Seagull, in North Carolina, before becoming executive director at Camp Cory. He only lasted one summer, but some of his songs have remained.

Modern Songs and Stories of Camp Cory

"The Rooster Song"
This song, as well as "What Do You Do with a Drunken Sailor?" was usually only sung on overnight Bluff trips. This was probably because counselors felt they could get away with being bawdier if they were not on camp grounds.

"The Second-Story Window"
Versions may contain any number of verses, including Old Mother Hubbard, Little Bo Peep and Old King Cole. The Camp Cory version consists of Jack and Jill, Little Miss Muffet, Humpty Dumpty and Little Jack Horner.

"Stack and Scrape"
Penned by counselors Chris Hart and Aaron Frishman in the early- to mid-1990s. The two counselors created the song after realizing that a stack and scrape tune was lacking. For the first few meals, just the two of them sang, but the song soon caught on. It has spawned a spinoff: "Scrape and Stack/ Put stuff back/Put it into a dish rack/Scrape 'em down/To the ground/ Scrap 'em swell and scrape 'em [very low pitch] wellllllll."

"Taps"
Composed by Major General Daniel Butterfield, Army of the Potomac, Civil War. Butterfield was born in Utica, New York, and received the Medal of Honor (in those days a quite common award) for rallying the Eighty-third Pennsylvania Regiment's Union troops to the flag during the Battle of Gaines Mill (the third of the "Seven Days' Battles"). Butterfield wrote "Taps" in July 1862 following the Seven Days' Battle because he was unsatisfied with the original "lights out" bugle, which was copied off a French call. The "taps myth" relates the account of Union Captain Ellicombe, who supposedly found his Confederate son dead on the battlefield. As the story goes, the son (or, in some versions, brother) had the notes to "Taps" written and kept on his person, and Ellicombe wished this music played at his son's funeral. This myth cannot be corroborated with historical evidence.

Some other verses to "Taps":
Fading light, dims the sight,
And a star gems the sky, gleaming bright.
From afar, drawing nigh, falls the night.

Thanks and praise, for our days,
'Neath the sun, 'neath the stars, 'neath the sky;
As we go, this we know, God is nigh.

Sun has set, shadows come,
Time has fled, Scouts must go to their beds
Always true to the promise that they made.

While the light fades from sight,
And the stars gleaming rays softly send,
To thy hands we our souls, Lord, commend.

From David Kenyon Webster's World War II memoir:
When your last Day is past,
Some bright star from afar O'er your grave,
Watch will keep, While you sleep, with the brave.

From the Arlington National Cemetery website's "History of 'Taps'":
Then good night, peaceful night,
Till the light of the dawn shineth bright,
God is near, do not fear—Friend, good night.

Stories

The Man Who Loved to Fly
I feel certain that this story must have been taken from a television show or from a book of science fiction short stories. An exhaustive search, however, has turned up no promising leads.

The Philadelphia Experiment
Dave Ghidiu brought this conspiracy theory to camp and made it a campfire story. The story is also commonly told in the "Cosmic Inquiries and Galactic Mysteries" class, which is offered irregularly. Dave Ghidiu worked from 1994 to 2001 and 2003 to 2009 (among other positions, he was leadership director 1999–2000, assistant director 2001, Maijgren Village head 2004, sailing master 2004–05 and program director 2006). He usually begins the story by telling of

where he first heard it. He was at a Syracuse University–Australia basketball exhibition game, with a friend of his who was in the army, and they adjourned to Applebee's for half-priced appetizers. There, the army friend told him a version of "The Philadelphia Experiment." Apparently, it is a pretty common tall tale among members of the U.S. military, especially the navy.

There really was a USS *Eldridge*. It was a *Cannon*-class destroyer escort, commissioned in 1943, and eventually sold to Greece after World War II was over. *The Case for the UFO*, by Morris K. Jessup, is real, as well. There are numerous details and asides that a storyteller can choose to communicate in telling "The Philadelphia Experiment"—Dave Ghidiu's written summary, on which I based my writing here, was itself six pages long. One can extemporize on the political and military climate from World War I into the 1940s, on whether the experiment created some sort of gravitational field, on the schematics and crew makeup of the *Eldridge* or on whether the experiment continued on into the 1990s (certain land in Long Island was supposedly used for the MK Ultra mind-control experiments and may have been responsible for downing TWA flight 800 in 1996), to name just a few options.

Purple Passion

This is apparently a fairly common version of the "shaggy dog" type story. This genre is so named for the eponymous story in which a boy keeps entering his dog in "shaggy dog contests" and keeps progressing up to the next level until he reaches the national championships, where the judges tell him, "That dog isn't so shaggy." In these stories, the audience is inevitably left disappointed at the climax, when it turns out that the story isn't resolved at all or is resolved in a pun. "Purple passion" can refer to a drink consisting of grape juice and grain alcohol.

Purple Passion Bear

Another "shaggy dog" story. In some versions, the narrator plucks a hair from the body of the Purple Passion Bear, and at the climax the bear reaches out with its clawed paw and plucks a hair from the narrator's head.

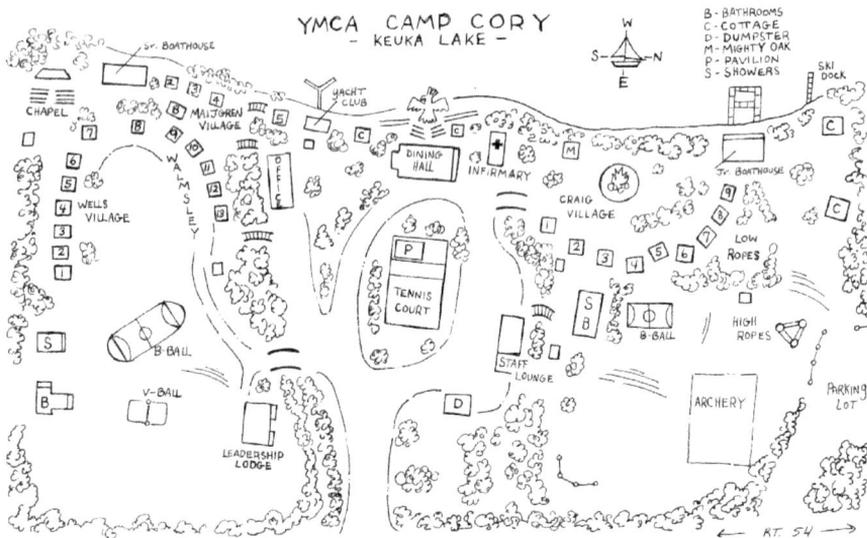

Created by Shawn Rowcliffe.

Appendix A
CAMP CORY'S DIRECTORS

EXECUTIVE DIRECTORS

1961–1972	Weldon B. "Chief" Hester
1973–1975	Roy Tulp
1976–1996	Barb Fisher
1997–2001	Ellie Orbison
2002	Rick Coyle
2003–present	Michele Rowcliffe

RESIDENT AND CAMP DIRECTORS

circa 1890s	"Colonel" S.P. (Samuel Parker) Moulthrop–Rochester YMCA Camp / Camp Iola
circa 1903–1905	C.A. McLaughlin [various names]
1906–1916	Frank E. Gugelman—Camp Iola [possibly interstitially]
1917	Mr. Van Geyt—Camp Iola [possibly other summers, as well]
1918–1925	Frank E. Gugelman—Camp Iola / Camp Cory
1926–1930	Dougal E. Young

1931–1935	Charles W. Carson
1936	George A. Brown
1937–1944	Bill Briggs
1945–1947	Bill Campbell
1948–1950	Sam Johnson
1951–1959	Weldon B. "Chief" Hester
1960	Carl Alford
1961	Weldon B. "Chief" Hester
1962–1963	Allan "Al" Finkle
1964–1965	Bob Smith
1966–1974	Neil Gray
1975–1996	Jerry Elliott
1997	Ellie Orbison
1998–2000	Michele Rowcliffe
2001	Dave Ghidiu
2002	Rick Coyle
2003–2010	Mark Dibble
2011–present	Patrick "Pat" Foster

APPENDIX B

SONGS AND STORIES NOT INCLUDED IN THIS COLLECTION

SONGS

There are certain songs I omitted, either because they are no longer sung with any sort of frequency, because they have been introduced too recently or because (like "Boom Chicka Boom" and "O! What a Beautiful Morning!") they are extremely generic and well known outside of Camp Cory.

"Baby Shark"

"Boom Chicka Boom"

"Highway 40" [*from* The Brak Show]

"If I Had a Boat" [Lovett]

"I Love the Mountains"

"O! What a Beautiful Morning!"

"Peter Built a Truck"

"Purple Stew" *(from Camp Seagull)*

"Scrape and Stack" *(but see note to "Stack and Scrape")*

"Stairway to Heaven" [Page/Plant] [*the last song played at any Senior Village dance*]

"Stand by Me" [King/Leiber/Stoller] [*sung by the CITs at a talent show near the end of their session*]

"Three Chartreuse Buzzards" / "Three Short-Necked Buzzards" *("short-necked" version from Camp Seagull)*

"The Twinkie Song"

"We Are Table Number 1"

Appendix B

Stories

The Bluff Story, aka "Entropy" [Isaac Asimov, "The Last Question," *Isaac Asimov: The Complete Stories, Vol. 1* (Broadway, 1990, orig. pub. 1956)]

The Dead Body Story

John Titor the Time Traveler

Purple Mongoose [*Told to all CITs before their entering cabins or becoming staff. Sometimes told to new staff during staff training. Dates back to at least the 1970s and involves an incident that occurred at Camp Cory.*]

The Story of Jaunting [Stephen King, "The Jaunt," *Skeleton Crew* (Putnam, 1985)]

The Viper [Alvin Schwartz, *Scary Stories to Tell in the Dark* (New York: HarperTrophy, 1981)]

ABOUT THE AUTHOR

B o Shoemaker is from Brighton, New York, and obtained degrees from SUNY Geneseo (BA in history), Fordham University (MA in history) and Syracuse University College of Law (JD).

He worked for eleven summers at Camp Cory as counselor, Waterfront coordinator, Maijgren Village head, leadership director, program director and eventually senior program director. He is currently the camp historian.

Visit us at
www.historypress.net

www.ingramcontent.com/pod-product-compliance
Lightning Source LLC
Chambersburg PA
CBHW060800100426
42813CB00004B/892